MW00608126

ENDANGERED SPECIES

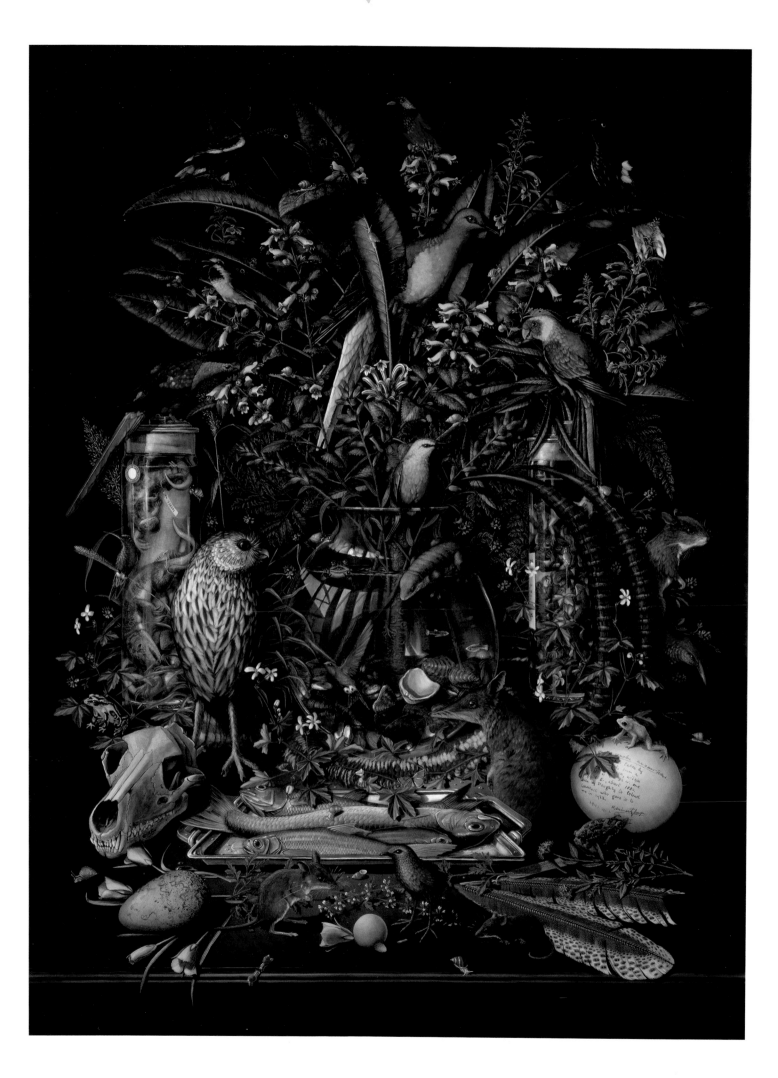

ENDANGERED SPECIES

ARTISTS ON THE FRONT LINE OF BIODIVERSITY

BARBARA C. MATILSKY

WHATCOM MUSEUM, BELLINGHAM, WASHINGTON

This publication accompanies the exhibition *Endangered Species: Artists on the Front Line of Biodiversity*, organized by Barbara C. Matilsky for the Whatcom Museum, September 8, 2018–January 6, 2019.

Major funding for the exhibition and catalogue has been provided by the National Endowment for the Arts and the Norcliffe Foundation, with additional support from the City of Bellingham, Whatcom Museum Foundation and Advocates, Alexandre Gallery, and Heritage Bank.

ART WORKS.
arts.gov

© 2018 by the Whatcom Museum. The copyright of works of art reproduced in this book are retained by the artists, their heirs, successors, and assignees.

All rights reserved. No part of this publication may be reproduced or transmitted in any form or by any means, electronic or mechanical, including photocopy, recording, or any information storage or retrieval system, without permission in writing from the publisher.

WHATCOM MUSEUM

Published in the United States by
The Whatcom Museum
121 Prospect Street
Bellingham, Washington 98225
www.whatcommuseum.org

First edition, 2018

Designed by Phil Kovacevich
Edited by Nancy S. Tupper
Indexed by Judi Gibbs

Printed in Canada by Friesens Book Division

Distributed by the University of Washington Press
P.O. Box 50096, Seattle, WA 98145
www.washington.edu/uwpress

ISBN: 978-0-692-08331-4
Library of Congress Control Number: 2018902987

The paper used in this publication has been certified by the Forest Stewardship Council.

Front cover:
ANDY WARHOL
Endangered Species, 1983
Bighorn Ram (Ovis canadensis); Siberian Tiger (Leo tigris altaica); Bald Eagle (Haliatus leucocephalus); African Elephant (Loxodonta africana); San Francisco Silverspot (Speyeria callippe callippe); Black Rhinoceros (Diceros bicornis); Pine Barrens Tree Frog (Hyla andersonii); Orangutan (Pongo pygmaeus); Grevy's Zebra (Equus grevy)
Silkscreen prints
38 x 38 in.
© 2018 The Andy Warhol Foundation for the Visual Arts / Artists Rights Society (ARS), New York / Ronald Feldman Fine Arts, New York
Photo: D. James Dee

Frontispiece:
ISABELLA KIRKLAND
Gone, from the *Taxa* series, 2004
Oil and alkyd on canvas over panel
48 x 36 in.
Private Collection

Back cover:
MADELINE VON FOERSTER
Carnival Insectivora (Cabinet for Cornell and Haeckel), 2013
Oil and egg tempera on panel
20 x 16 in.
Collection of John Brusger

CONTENTS

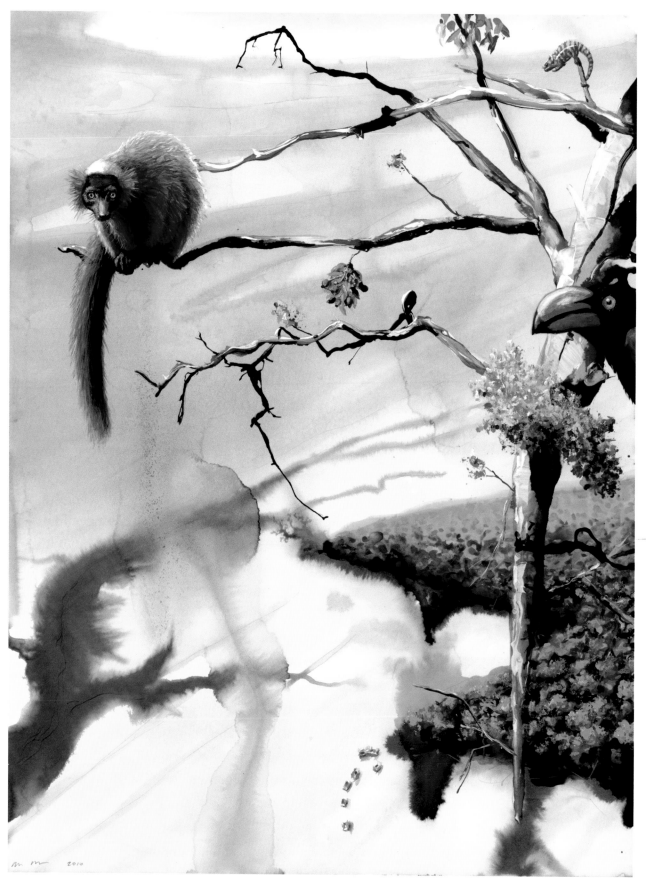

Alexis Rockman, *Fragments*, 2010.

FOREWORD

The Whatcom Museum is both pleased and proud to present *Endangered Species: Artists on the Front Line of Biodiversity,* a sequel exhibition to *Vanishing Ice: Alpine and Polar Landscapes in Art* (2013–14), curated by Whatcom Museum Curator of Art Dr. Barbara Matilsky. After more than five years of research, viewing hundreds of artworks and engaging in conversations about the topic with artists, curators, and galleries, once again Dr. Matilsky has skillfully assembled a world-class exhibition. Her careful analysis of works created by both early and contemporary artists whose subject matter focuses on Earth's biodiversity shows the fragility of our planet and the ever-increasing threat to the natural environment from human interventions such as global warming, deforestation, and pollution, as well as from natural causes.

At the heart of Whatcom Museum's mission is the exploration of our natural, cultural, and historical landscapes. The splendor and vulnerability of our planet is magnificently portrayed in the telling of touching and fascinating stories around several basic themes: the beauty and immensity of Earth's biodiversity, natural extinctions, human-influenced extinctions, endangered species, trophy hunting, and of course, global warming. Our hope is that by creating awareness about the magnitude of these growing phenomena through an accessible gallery setting, visitors can experience thought-provoking artwork by artists and scientists and learn firsthand about our earth's plight.

This exhibition would not be possible without the generous support from the National Endowment for the Arts and the Norcliffe Foundation, both early supporters of *Vanishing Ice.* Special thanks to Phil Kovacevich for his outstanding catalog design, Nancy Tupper for her meticulous editing, and Judi Gibbs for her thorough indexing. This exhibition, including all the complexities of its development, has depended upon an entire cadre of Whatcom Museum professionals who worked tirelessly from its inception to final installation. Special thanks to Director of Exhibitions Victoria Blackwell and her team, Scott Wallin and David Miller, for the "magic" they work to highlight the exhibition in its best physical form; Curator of Collections Rebecca Hutchins, for executing all the loan agreements and accompanying paperwork; Marketing and Public Relations Manager Christina Claassen; Membership and Development Manager Althea Harris; Director of Learning Innovation Susanna Brooks; and Chief Financial Officer Charles Marcks. We are also indebted to the City of Bellingham and Mayor Kelli Linville for the ongoing support the museum has received over the years, and to the Whatcom Museum Foundation, Museum Advocates, Alexandre Gallery, and Heritage Bank for additional support.

On a final note, this exhibition provides hope for the future. Artists themselves are not only creating works that draw attention to environmental problems, but they are also designing projects that help restore habitats. It is our fervent hope that visitors will be inspired and take notice of these positive changes so that they feel empowered, even if in small ways, to help make a difference.

PATRICIA LEACH
EXECUTIVE DIRECTOR

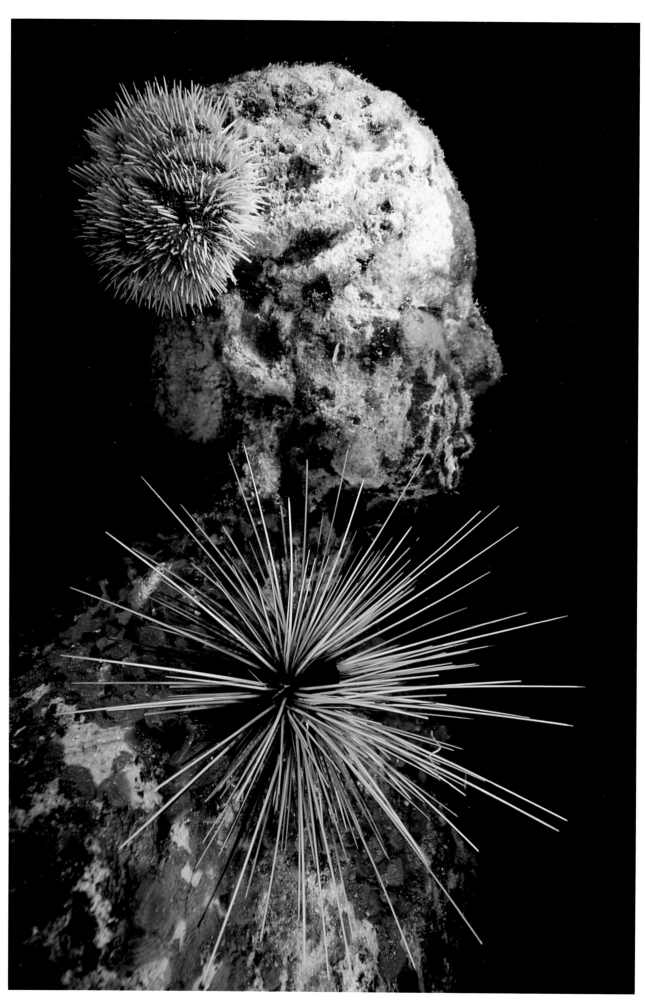

Jason deCaires Taylor, The Silent Evolution (Veronica), 2011, detail from underwater sculpture installation, Isla Mujeres, Mexico.

ACKNOWLEDGMENTS

Endangered Species was conceived to complement the traveling exhibition *Vanishing Ice: Alpine and Polar Landscapes in Art* (2013), which provides a cultural perspective for understanding the phenomenon of climate change. In the art of such sublime geographic regions, humans and other life forms are often reduced to insignificance. While experiencing these works in the exhibition galleries, I realized that a crucial environmental narrative was absent yet unfolding simultaneously.

Against the harrowing backdrop of climate change, human activities have severely impacted the planet's biodiversity. Many people outside the scientific community remain unaware of the massive loss of habitat and wildlife that could portend Earth's sixth mass extinction. Inspired by their love of nature and keen interest in the biological sciences, many artists have quickly responded by making emotional and thought-provoking works to awaken human consciousness to this crisis.

Artists have always been in the vanguard of mediating a balanced relationship between *Homo sapiens* and the natural world. This was the premise of my early exhibition *Fragile Ecologies: Contemporary Artists' Interpretations and Solutions* (1992), which highlighted artworks that revived habitats and enhanced biodiversity. In many ways, *Fragile Ecologies* laid the conceptual framework for *Endangered Species*.

Five years in the making, *Endangered Species* would not have been possible without the artists whose inspiring works provided clarity and hope when research led to moments of despair. Their commitment to wildlife and the conservation of nature empowered me to focus on positive messaging to help galvanize action.

Thank you to Whatcom Museum Executive Director Patricia Leach, who supported this project from its genesis. She believed in its educational relevance for meeting the challenges facing the planet today.

I appreciate the many museums, galleries, libraries, and private collectors who shared their precious works of art; citations of these individuals and entities can be found in the artists' entries and the exhibition checklist. I am grateful to the Alexandre Gallery of New York for financing the transport of Tom Uttech's painting. A special thank you to Ronald Feldman and Marco Nocella of Ronald Feldman Fine Arts, who have supported my work since *Fragile Ecologies* and made possible the loan of Andy Warhol's *Endangered Species* portfolio.

Humanity's youth has the most to gain or lose by the environmentally sensitive decisions made today. I was constantly reminded of this fact while working with Monica Hope, my Western Washington University (WWU) work-study student. From her perspective as a student of natural science, she helped me with many aspects of *Endangered Species*. I also appreciate the work of Olivia Harris, an art history major at WWU, who assisted in condensing the multiple layers of exhibition text into a cohesive presentation.

My deepest gratitude to Jyoti Duwadi for his encouragement throughout the process of organizing Endangered Species, and to Douglas Taylor for his enthusiasm for and support with the exhibition catalogue.

The generosity of both the National Endowment for the Arts and the Norcliffe Foundation made *Endangered Species* a reality. This combination of public and private funding is essential for the arts to thrive. I am especially proud of the City of Bellingham, whose financial contribution and progressive values support the Whatcom Museum in tandem with the Whatcom Museum Foundation and Museum Advocates.

—BCM

INTRODUCTION

Endangered Species presents the work of sixty artists from around the world who convey both the wonder and fragility of life on Earth. Through an ever-expanding range of styles and media, these artists help us grasp the magnitude of looming plant and animal extinctions. They spotlight the human actions that threaten life as well as revitalize habitats through art projects that reconnect people to the natural world.

Spanning two hundred years, the works in *Endangered Species* reflect the vital relationship between art and natural science. These fields share the creative processes of exploration, observation, and interpretation that permeate the exhibition's overlapping themes.

By tracing links between contemporary and earlier artists, *Endangered Species* highlights art's pivotal contribution to an enduring cultural legacy of nature conservation. Heightened public awareness has translated into landmark acts of national and global environmental protection. Artists nurture this tradition of engagement, creating works that inspire individuals and communities to value biodiversity. Ultimately, the health and survival of our own species hinges upon respect for life and the stewardship of the planet's unique ecosystems.

We stand now where two roads diverge. But unlike the roads
in Robert Frost's familiar poem, they are not equally fair.
The road we have long been traveling is deceptively easy,
a smooth superhighway on which we progress at great speed,
but at its end lies disaster.

The other fork of the road, the one "less traveled by" offers our
last, our only chance to reach a destination that assures the
preservation of our earth. The choice, after all, is ours to make.

—RACHEL CARSON, *Silent Spring*, 1962

CELEBRATING BIODIVERSITY'S BEAUTY AND COMPLEXITY

From Landscapes to Microscopic Imagery

From so simple a beginning endless forms most beautiful
and most wonderful have been, and are being, evolved.

—CHARLES DARWIN, *On the Origin of Species*, 1859

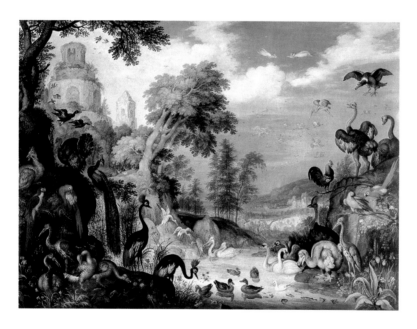

ROELANT SAVERY, *Landscape with Birds*, 1628,
oil on panel, Kunsthistorisches Museum, Vienna.
After making several sketches of a live dodo that
was transported to Europe, Savery included the bird
in a few landscape paintings. Note the dodo at the
bottom right of the composition.

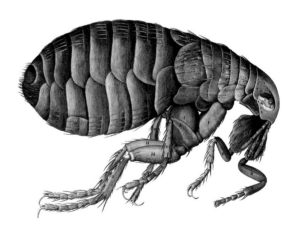

ROBERT HOOKE, engraving of a flea, from
*Micrographia: or Some Physiological Descriptions of
Minute Bodies Made by Magnifying Glasses*, 1665. This
image is from the first book to illustrate life as seen
through a microscope.

Biodiversity (or biological diversity) refers to the variety of all living things. It includes the diversity of species, life's genetic diversity, and the multiplicity of the planet's ecosystems. Biodiversity can be measured by the number of species in a defined area or, more broadly, on the entire earth.

Artists illuminate biodiversity's stunning variety on its most grand and intimate scales. In imaginary landscapes, they portray the essential connection between flora and fauna within complex environments of infinite patterns and colors. Artists also isolate details of single plants or animals to capture the elegant structures that support a species' survival.

During the eighteenth century, artists and natural scientists began systematically documenting the astonishing array of life from near and distant lands. Beginning with Captain Cook's Pacific expeditions (1768–1780), European voyages of discovery contributed to an encyclopedic cataloguing of the world's plants and animals.[1]

These journeys supported the growing market for illustrated expedition journals, natural history books, and medicinal plant herbals. Popular publications encouraged people to collect and draw specimens as they observed nature close to home. A similar spirit of exploration exists today. Citizen scientists use computer applications to upload photographs into a growing geographical database of species.

Documentation of plants and animals remains critically important for artists and natural scientists as species disappear far faster than new ones are discovered. Biologists have counted one hundred new species of birds in the past twenty-five years, adding to the 8.7 million species of flora and fauna known to exist.[2] Largely due to habitat destruction, precious forms of life vanish before humans ever get to know them. Responding to this crisis, the artist's role in inspiring awareness of biodiversity has increased since the term was introduced in the 1980s.

Nature's bounty has influenced the arts and rituals of people around the world far beyond Western art history. Biodiversity's cultural and spiritual significance emerges from its necessity for human survival. Even if humans were not dependent on the food, medicine, energy, and shelter provided by life's abundance, biodiversity holds its own intrinsic value. The work of artists and natural scientists affirms the ethical right of every species and ecosystem to survive and thrive.

NOTES

1 The Swedish botanist Carl Linnaeus (1707–1778) made this work easier by establishing the first straight-forward classification system. Using two names to describe a genus and species with common characteristics, scientists were better able to communicate with each other.

2 See Camilo Mora et al., "How Many Species Are There on Earth and in the Ocean?," in PLoS Biol 9, no. 3 (August 23, 2011): 8, https://doi.org/10.1371/journal.pbio.1001127. See also Ceballos, Ehrlich, and Ehrlich, *The Annihilation of Nature: Human Extinction of Birds and Mammals*, (Baltimore: Johns Hopkins University Press, 2015), 5.

Tom Uttech

American, b. 1942
Nin Maminawendam, 2006
Oil on canvas, 73¼ x 78¾ in.
Collection of the Tucson
Museum of Art, Gift of the
Contemporary Art Society,
2009.5.1

> My painting is an attempt to share the state of mind
> I can enter when alone in the Northwoods.
>
> —Tom Uttech

Tom Uttech's imaginary landscapes embody his explorations of the boreal forests and waterways of northern Minnesota, Wisconsin, and Ontario's Quetico Provincial Park. Paintings abundant with animals that once roamed a pristine landscape are titled in the Ojibwe language to honor the Native Americans who originally inhabited these sites. *Nin Maminawendam* means "I am fond of it" or "I don't want to part with it," a sentiment that describes Uttech's attachment to this unique environment.

Nin Maminawendam belongs to a series often called migration paintings, where raptors and song birds fill the sky, moose ply the waters, and wolves move freely among the evergreens. An inveterate bird watcher who has identified more than three hundred species, Uttech lavishes particular attention on his splendid aviary. The fantastic animals carved by the artist into his frames playfully expand the world's compendium of known species. Although Uttech may have been unaware of Roelant Savery's *Landscape with Birds* (page 12), *Nin Maminawendam* parallels the seventeenth-century artist's vision of biodiversity.

Uttech conjures a private realm of animals where people do not enter but rather witness and contemplate the relationship between species and ecosystems. Beneath the stunning profusion of life, we become aware of a forest damaged perhaps by the pollution of acid rain. Or, the forest clearing may simply provide expansive vistas into the magical meeting of land, water, and atmosphere.

Staged in a forest tinged by a golden sunset, Uttech's dramatic light pays homage to the sublime tradition of Hudson River landscape painters such as Albert Bierstadt. Against this background, the tawny autumn colors underscore the urgent and uniform movement of his animal kingdom.

Uttech purposely conveys an aura of wilderness biodiversity to inspire people to directly experience the natural world. He recognizes that only through personal communion with the outdoors will the earth be treasured rather than trampled.

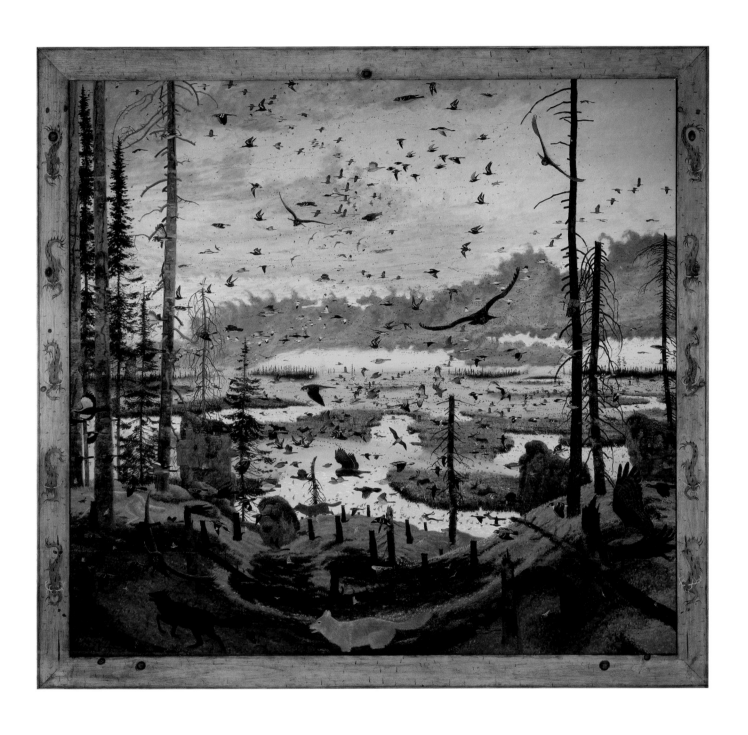

Fred Tomaselli

American, b. 1956
Gravity in Four Directions, 2001
Leaves, pills, printed paper,
acrylic and resin on wood panel,
72 x 72 in.
Courtesy of Paul G. Allen Family
Collection

I tend to see each small bit like an individual cell, a piece of
binary code, or a strand of DNA that accumulates, accrues,
and grows into my images.

—Fred Tomaselli

Fred Tomaselli's cosmic landscape evokes the phenomenon of gravity that
permeates the universe. Emerging from dense black space, interconnected
force fields orbit in four directions. Upon closer examination, these strands
of energy reveal details of Earth's biodiversity—collaged images of birds,
flowers, insects, hemp leaves, and human hands and eyes—suspended in
thick layers of resin.

Tomaselli embeds pharmaceuticals alongside his beaded strings of
life. Their placement suggests the ubiquity of drugs in human culture and
makes palpable the painting's hallucinatory composition. The necklace-like
pills also recall the individual cells that define the essence of organisms.

Weaving together plants, animals, and pills within the axis of four
directions, Tomaselli alludes to the power of healing through the spiritual
traditions of Native American medicine wheels and Tibetan Buddhist
mandalas. Each direction, represented by a different color, symbolizes the
cycle of life. Here, humanity finds alignment within the larger ecosystems
of nature and, more grandly, the cosmos itself.

David Liittschwager

American, b. 1961
Costa Rica Collage, from *A World
in One Cubic Foot,* 2012
Archival inkjet prints
30 x 20 in. and 30 x 60 in.
Courtesy of the artist

Orchids, ferns, and bromeliads form living layers on the
mossy bough, sprouting one atop another and creating
canopy soil. They gather moisture from the rain and mist and
vie for space in the sun. Most of the animals that thrive in
this treetop ecosystem are fingertip small beetles, ants, moths,
and spiders—and prey for larger tree dwellers like rodents
and monkeys. Insects and birds, including hummingbirds, do
much of the pollinating, while the nimble-footed mammals
serve as vital dispersers of seeds.

—David Liittschwager

David Liittschwager captures all the luxuriant life observed in one cubic
foot of Costa Rica's Monteverde Cloud Forest Biological Reserve. It is
one of six ecosystems (including New York's Central Park) explored in his
book *A World in One Cubic Foot: Portraits of Biodiversity,* introduced by the
renowned biologist E. O. Wilson.

Liittschwager puts a unique spin on the work of nineteenth-century
natural scientists who observed, collected, and classified newly discov-
ered forms of life. Collaborating with biologists from Monteverde's
Biodiversity Institute, the artist climbed one hundred feet up a strangler
fig tree to site a twelve-inch aluminum cube on a stout limb in the forest
canopy. He then carefully gathered the plants and animals living in and
passing through the metal frame.

After photographing 150 different specimens in isolation from their
environment, Liittschwager recombined his images of flora and fauna into
a modular, grid-like montage. His *Costa Rica Collage* is reminiscent of the
way that early artist-scientists systematically pinned and organized collec-
tions, such as beetles and butterflies, behind glass. By studying the displays
and storage cabinets at natural history museums over the years, the artist
intuitively absorbed and reinterpreted this technique of presenting the
beauty and variability of life.

Martin Johnson Heade

American, 1819–1904
Cattleya Orchid, Two Hummingbirds and a Beetle,
ca. 1875–1890
Oil on canvas
14¼ x 22¼ in
Crystal Bridges Museum of American Art, Bentonville, Arkansas, 2010.67

Martin Johnson Heade invites viewers to closely examine his Proto-Surrealist view of orchids and sun gem hummingbirds. Suspended in the rainforest canopy, plants and animals loom larger than life when placed adjacent to a distant, snow-capped peak. The artist's magnified scientific view encompasses small lifeforms—a beetle, lush lichens, and hanging Spanish moss—as well as the meteorological effects signaling an impending storm.

Heade was spellbound by hummingbirds, which he raised throughout his life. He collected taxidermy skins for study and carried sugar water on walks to attract the tiny birds. Between 1880 and 1904, the artist wrote more than one hundred letters and articles about hummingbirds and related topics for *Forest and Stream*, the leading conservation magazine of its time.

Inspired by John James Audubon's *Birds of America* (1827-1838), Heade journeyed to the rainforest in 1863 to document hummingbirds in their native ecosystem for his book, *The Gems of Brazil*. Titled after the striking, iridescent feathers of these small creatures, the book was never published due to financial constraints. Heade did complete more than twenty paintings that were avidly collected during this period.

The artist made two additional expeditions to the tropics in 1866 and 1870. After his final trip to Panama, Columbia, and Jamaica, he began painting hummingbirds with the *Cattleya labiata* orchid. They became the central motif in a series of fifty-five paintings made between 1871 and 1902.

Heade's close observation and interpretation of life within a complex, biodiverse environment was reinforced by the natural scientist Alexandre von Humboldt, whose popular book *Kosmos* (1845–1862) urged artists to explore tropical habitats. The artist was also motivated by his friend Frederic Edwin Church, whose celebrated landscape *Heart of the Andes* was exhibited in 1859. In contrast to Church's panoramic compositions, Heade painted on an intimate scale, blurring the boundaries between landscape and still life.

An inveterate traveler, the artist also visited British Columbia and California. He settled in St. Augustine, Florida, in 1883 and became one of the first prominent artists to paint the state's marshes and swamps.

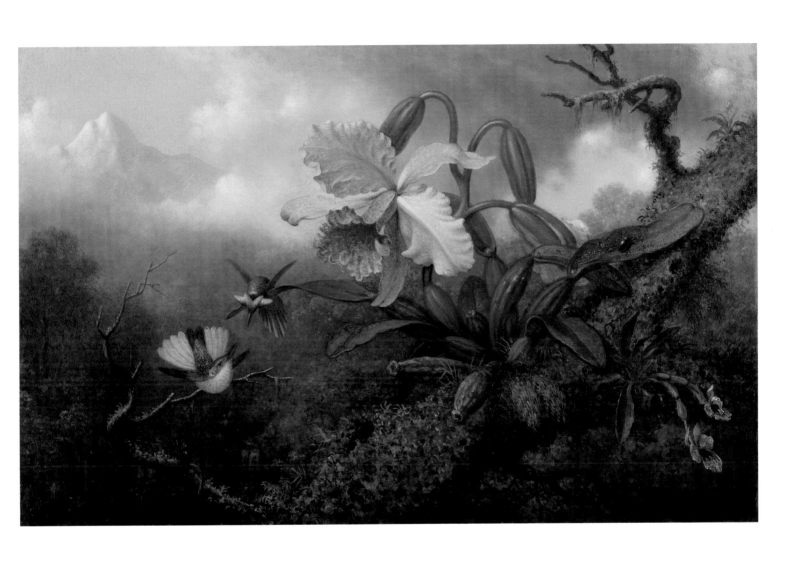

Sanna Kannisto

Finnish, b. 1974
Private Collection, 2003
Digital C-print
51 x 63 in.
Courtesy of the artist

Flower Arrangement, 2010
Digital C-print
27⅝ x 22½ in.
Courtesy of the artist

In this staged self-portrait of the artist as natural scientist, Sanna Kannisto consciously evokes the nineteenth-century tradition of exploration and discovery. Since the 1990s, the artist has made eight journeys to the rainforests of Central and South America, where she works alongside scientists at biological field stations. In these locations, Kannisto composes and photographs unusual still lifes such as *Flower Arrangement*.

Sanna Kannisto isolates her subjects from their natural environment in this still life of a bat sucking nectar from a bromeliad flower. She unexpectedly includes scientific tools, which appear to hold the composition together.

The man-made intrusion into the natural beauty of this scene, dramatically lit against a black backdrop, lends a critical edge to the photograph. By inserting implements used to study and document specimens, Kannisto obliquely questions scientific attempts to contain, control, and define nature. When interviewed, she often wonders aloud whether science and her chosen medium of photography can be truly objective in their pursuit of knowledge.

Despite this critique, the artist's admiration for the tradition of the artist-naturalist becomes apparent when comparing *Flower Arrangement* to the work of Maria Sibylla Merian. The early artist spent two years in South America studying and drawing plants and insects. In 1704, she published the *Metamorphosis of Insects in Surinam* to international acclaim. Both artists focus on a particular species and its food source to illuminate the symbiotic relationship between flora and fauna.

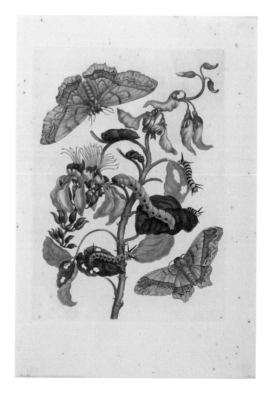

MARIA SIBYLLA MERIAN, *Caterpillars, Butterflies (Arsenura armida) and Flower (Pallisaden Boom: Erythrina fusca)*, plate 11 from *Metamorphosis Insectorum Surinamensium*, 1705, hand-colored etching and engraving, Minneapolis Institute of Art.

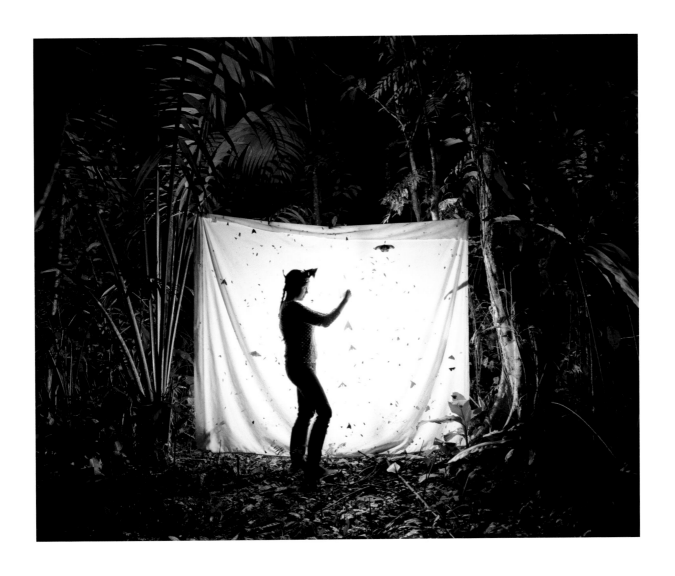

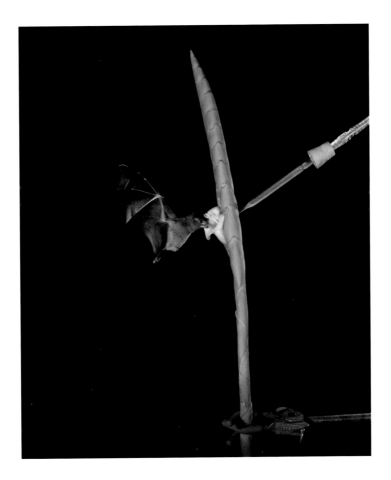

Mark Dion

American, b. 1961
Scala Natura, 2008
Offset color lithograph
50½ x 40 in.
Courtesy of the artist and Tanya
Bonakdar Gallery, New York

Mark Dion invents a distinctive classification system that charts the microbial beginnings of life and ends with the artifacts of civilization. The final image in his graphic grid of the animal kingdom is the metronome, which symbolizes the passing of time.

In a nod to Darwinian evolution, Dion places man and woman last among an array of species. He ironically appropriates images of the biblical Adam and Eve, famously engraved by the Renaissance artist Albrecht Durer, for his human icons.

Placing humanity at the bottom of his print, Dion challenges scientific ideas first expressed by Aristotle (384–322 BCE) in *The History of Animals*. In the Greek philosopher's early attempt to classify Earth's biodiversity, man reigned at the apex of a hierarchy of species. Aristotle's ladder of nature, *Scala Natura*, became the title for Dion's work.

One of Dion's many versions of *Scala Natura* includes a sculpture of actual specimens, displayed on an ascending staircase and topped with the bust of Aristotle. By referencing the history of science, the artist calls into question persistent beliefs about human superiority over life.

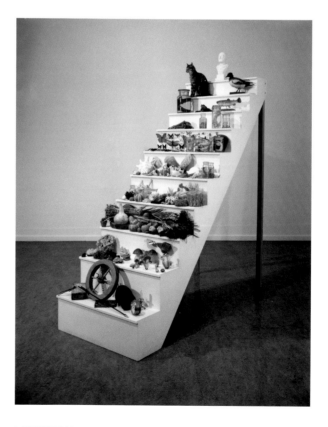

MARK DION, *Scala Natura*, 1994; stepped plinth,
artifacts, specimens, taxidermic animals, and bust.
Courtesy of the artist and Tanya Bonakdar Gallery,
New York.

MARK DION

PRINTED IN NEW YORK BY
ENGRAVERS MR. A. AUSTIN & MR. M. BASHER

Ernst Haeckel

German, 1834–1919
Hexacoralla, from *Kunstformen der Natur* (*Art Forms of Nature*), 1904
Lithograph
14¼ x 11 x 1⅜ in.
Courtesy of Linda Hall Library of Science, Engineering, and Technology, Kansas City, Missouri

As our mother earth is a mere speck in the sunbeam in the illimitable universe, so man himself is but a tiny grain of protoplasm in the perishable framework of organic nature.

—Ernst Haeckel, *The Riddle of the Universe*, 1901

Both biologist and artist, Ernst Haeckel created a unique encyclopedia of life illustrated with dazzling imagery that popularized biodiversity. One hundred prints of plants and animals were selected from thousands of sketches for his influential book *Art Forms of Nature*.

In *Hexacoralla*, Haeckel illustrates fifteen different corals, including star-shaped specimens and reef colonies like the brain coral depicted in the center. Although intensely colorful in reality, the corals are purposely portrayed in black and white to highlight their six-fold symmetrical structure. The beauty of Haeckel's precisely defined shapes accentuates the visual complexity and harmony within the natural world.

During his travels, Haeckel discovered several thousand new species, some of which appear in *Art Forms of Nature*. His legacy inspired the early twentieth-century Art Nouveau movement as well as artists Courtney Mattison, Madeline von Foerster, and Brandon Ballengée, whose works are included in *Endangered Species*.

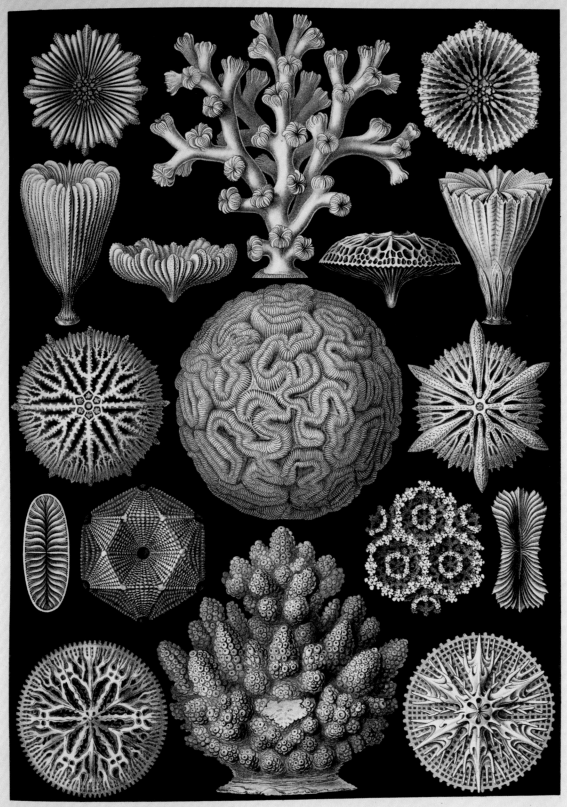

Hexacoralla. — Sechsstrahlige Sternkorallen.

William P.C. Barton

American, 1786–1856
Cornus Florida L. from *Vegetable Materia Medica of the United States*, vol. 1, 1817–1818
Engraving, hand-colored by Esther Barton
10¼ x 7⅞ in.
Courtesy of Linda Hall Library of Science, Engineering, and Technology, Kansas City, Missouri

William Barton was a US Navy physician and surgeon whose passion for botany guided his illustrated book on medicinal plants. He drew fifty specimens directly from nature and described the properties of each plant in its native habitat.

Barton's elegant drawing of the Florida dogwood displays details of the twig, flower, and fruit. Described by the artist as "among the best tonics of our country," the plant was used for intermittent fevers, malaria, and pneumonia. Currently, the Florida dogwood is listed as endangered in Maine, threatened in Vermont, and vulnerable in New York.

Vegetable Materia Medica, considered a botanical classic, is a significant example of a scientist-artist documenting and disseminating knowledge of Earth's plant diversity. For the first time, people in North America no longer had to rely on European-written herbals that contained little information on New World plants. The book informed students of medical botany, which Barton taught at the University of Pennsylvania.

NOTES

Fig 1: Represents a flowering twig of dogwood, at which time the young leaves are small

Fig. 2: The fruit and leaves of autumn

Fig. 3: A single flower, with stamens, petals, and calyx

Fig. 4: The calyx and pistil

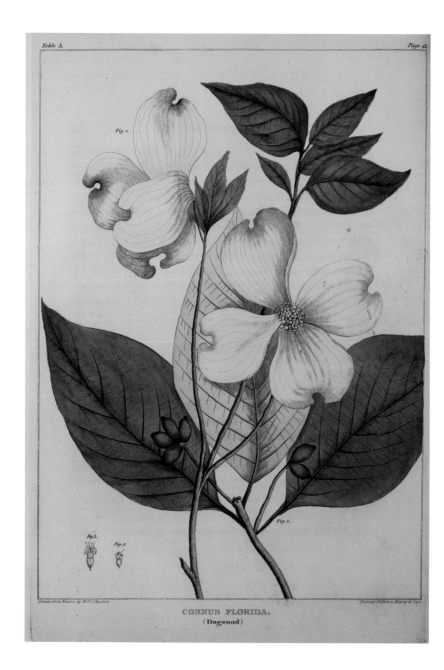

CORNUS FLORIDA.
(Dogwood)

Macoto Murayama

Japanese, b. 1984
Commelina communis L.
front view – ow, 2011
C-print
39½ x 39½ in.
Courtesy of Frantic Gallery,
Tokyo

The detailed complexity of a single Asiatic dayflower, a native plant that produces the blue dye used in Japanese woodblock prints, is heightened in this work by Macoto Murayama. Fusing the traditional methods of natural science with new technologies, the artist uncovers the hidden patterns and dimensions of plant anatomy.

Murayama begins by collecting and dissecting flowers. After closely examining each section under a magnifying glass, he records his observations in sketches and photographs. Elegant forms and structures are then revealed through modeling in 3-D computer software. The whole specimen comes together when separate parts of the flower are digitally rendered into a final composition. Murayama completes the artwork with scientific labels, measurements, and scales.

Inspired by architectural plans, Murayama creates what he calls "blueprints of nature." The work also reflects ideas published in Alexander von Humboldt's book *Kosmos* (1845–1862). Considered one of the first environmentalists, Humboldt believed that art surpassed science in its ability to convey Earth's unity in all its diversity. This ecological concept could be communicated by artists who meticulously studied the elemental patterns of nature. Murayama's work exemplifies this central tenet of Humboldt's natural philosophy.

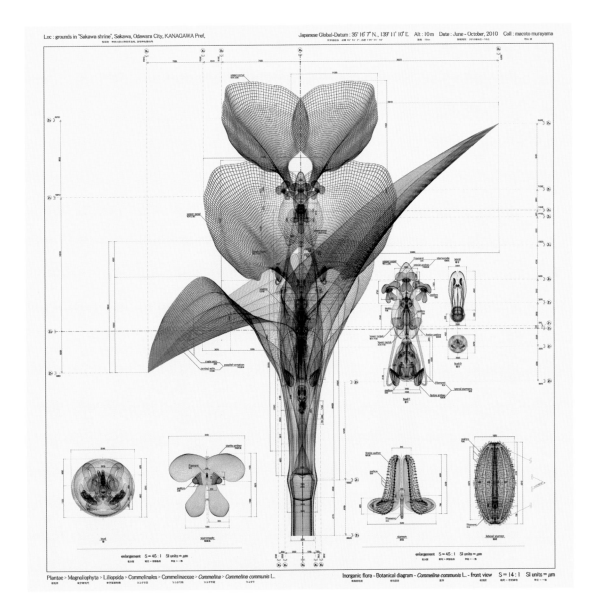

Carl Strüwe

German, 1898–1988
Diatoms Actinoptychus heliopelta,
1928, printed late 1950s
Gelatin silver print
6 ⅛ x 5⅛ in.
© 2017 by Carl Strüwe Archive,
Prof. Dr. Gottfried Jäger,
Bielefeld/VG Bild-Kunst, Bonn,
Germany
Courtesy of the Steven Kasher
Gallery, New York

Within the dizzying diversity of life, magnificent worlds of form lay hidden. Carl Strüwe spent more than thirty years revealing the intricate patterns, repetitive symmetry, and balanced geometries in the structures of plants and animals.

Joining a camera lens to the eye piece of a microscope, Strüwe created a series of 280 photographs. The artist began by purchasing images from a company that sold biological slides to scientists. He experimented with lighting and framing devices to obtain the desired effects. The photographs were compiled into a book, *Forms of the Microcosmos (Formen des Mikrokosmos)*, published in 1955.

Strüwe singled out diatoms, single-celled algae that live in water everywhere. He created many microphotographs of these organisms that form the foundation of the food chain and supply 25 percent of the world's oxygen. Diatoms also function as environmental indicators, signaling to scientists when an ecosystem is stressed.

Using multiple exposures and combining negatives, Strüwe creates a swirling composition of intricate patterns radiating from the center. The circular diatom resembles a mandala, a holistic symbol that appears in many cultures worldwide. This biological and cultural relationship underscores the importance of nature for spiritual sustenance.

One of the artist's photographs of diatoms graced the cover of the textbook *Life: An Introduction to Biology* (1957). By merging science and art, Strüwe became a pioneer of microphotography.

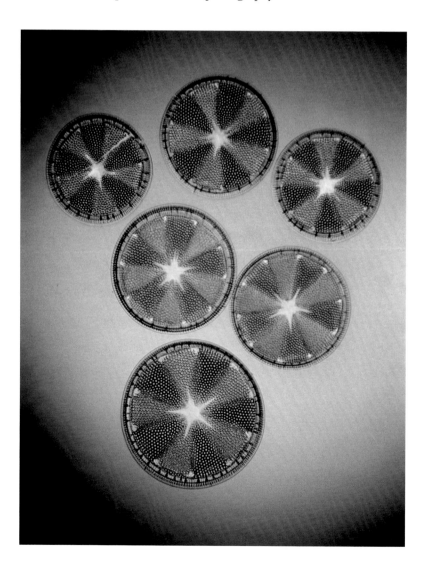

Roman Vishniac

American, b. Russia, 1897–1990
Cross Section of a Pine Needle,
early 1950s–late 1970s, printed
2017
Archival digital inkjet print
9 x 13 in.
© Mara Vishniac Kohn,
Courtesy International Center of
Photography

In Roman Vishniac's photograph, a slender pine needle explodes into a universe of expanding cells. Utilizing polarized light and high-magnification microscopes, the biologist-artist invented a technique of colorization to illuminate more refined details of life's complex architecture.

Vishniac's reverence for life and his desire to capture the essence of an organism compelled him to photograph a diverse range of specimens directly from life. This approach contrasts with the methodology of Carl Strüwe, who used pre-made slides to similarly magnify structural worlds hidden from the naked eye.

Renowned for his images of Eastern European Jewish culture prior to World War II, Vishniac became recognized for his innovations in color microphotography in the 1950s. His fascinating work and life was profiled in popular publications, including *Life* magazine (1951) and the *New Yorker* (1955). Vishniac's photographs also appeared on the covers of prominent scientific journals such as *Omni*, *Science*, and *Nature*.

In 1960, the National Science Foundation commissioned Vishniac to direct and film an educational series titled *Living Biology*. He made significant contributions to the burgeoning field of micro-cinematography through the 1970s. During this time, he held a unique position as professor of biological education at the Albert Einstein College of Medicine in New York City, where he melded his passion for science and art.

MAMMOTHS AND DINOSAURS
Interpreting Natural Extinction

Why has not anyone seen that fossils alone gave birth to a theory about the formation of the earth, that without them, no one would have ever dreamed that there were successive epochs in the formation of the globe.

—GEORGES CUVIER, *Discourse on the Revolutionary Upheavals on the Surface of the Earth*, 1825

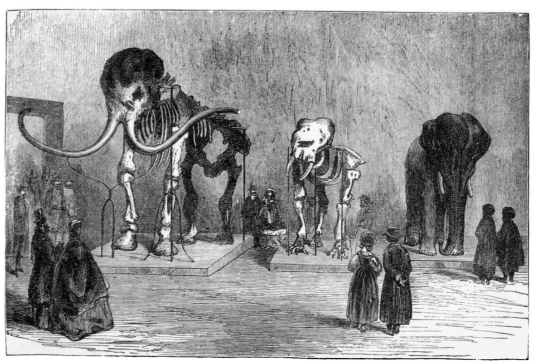

XXVI.—Skeleton of the Mammoth in the St. Petersburg Museum.

ÉDOUARD RIOU, engraving of woolly mammoth skeleton next to two Indian elephants, for size comparison, in a museum in Saint Petersburg, Russia. The mammoth was found frozen in Siberia and excavated by Michael Friedrich Adams, a Russian naturalist, in 1806. Illustration from Louis Figuier's *The World Before the Deluge*, 1867, American edition.

Mammoth and dinosaur fossils were among the missing links to understanding life during the planet's 4.5-billion-year history. The artists who interpreted these discoveries presented convincing visions of animals roaming primeval habitats shaped by geological changes over vast epochs. These revelations, which contributed to what is now called "deep time," were first published in best-selling, illustrated books and magazines. Sharing these startling views of Earth's past became a popular form of family entertainment.

The concept of extinction—the complete loss of an animal or plant species—first came to prominence during the nineteenth century, when the analysis of fossils unlocked mysteries of the planet's lost worlds. In the early 1800s, Georges Cuvier, an expert in comparative anatomy, studied petrified skeletons of mammoths and bones of contemporary elephants. He concluded that the fossils belonged to a different species from a past era. A new concept of Earth as ancient and ever-changing slowly replaced a static, theological view of life.

The hunt for fossils became a craze in Europe and the Americas. With each new find, a more detailed narrative of early life and its environment crystallized. The story of prehistoric biodiversity unfolded more majestically during the late nineteenth and early twentieth centuries, when natural history museums began commissioning artists to paint panoramic murals. Their works provided the context and ambiance to experience galleries filled with awesome skeletons of mammoths and dinosaurs.

In the 1980s, paleo art developed into a specialized field for artists working alongside paleontologists, who study fossils of extinct life and ancient ecosystems. The artistic legacy of mammoths and dinosaurs in popular culture endures in such films as *Jurassic Park* (1993) and *Ice Age* (2002), which have made these charismatic animals relevant to new audiences.

Mammoths and dinosaurs, emblematic of Earth's deep history, provide perspective on humanity's current impact on other species. Their existence and demise emphasize the vast stretch of time required for building biodiversity. By contrast, the late planetary arrival of humans a mere three hundred thousand years ago has triggered the precipitous depletion of other species in a cosmic blink of an eye. As the fossil record shows, recovery from the loss of biodiversity takes eons. The work of scientists and artists who interpret naturally occurring extinction helps us contemplate the consequences of the current unraveling of biodiversity.

EARTH'S MASS EXTINCTIONS

Before Homo sapiens appeared on the planet, a small number of extinctions regularly occurred as part of life's evolution. In contrast to the slow rate of "normal background" extinctions, the fossil record also reveals five mass extinctions that forever transformed the course of life.

These catastrophic biological events each marked the death of more than 70 percent of life over a relatively short geologic time span. The most widely known mass extinction wiped out the dinosaurs after an asteroid crashed into the Gulf of Mexico. Scientists believe that changes to Earth's atmosphere and oceans, due to global cooling, warming, or both, set the stage for mass extinctions.

Leading biologists now warn of a sixth mass extinction, a "biological annihilation" of both endangered species and populations of more common animals.[1] For the first time, the cause will be human activities: habitat loss, invasive species, pollution, population growth, overhunting and fishing, and global warming generated by carbon emissions.

But there is encouraging news. Plants and animals have responded positively to measures that protect and revive habitats around the world. From planting forests in Africa to establishing marine protected areas in the South Pacific, the resiliency of life within these reserves urgently underscores that more can be achieved to mitigate a mass extinction event.

NOTES

1 Gerardo Ceballosa, Paul R. Ehrlich, and Rodolfo Dirzo, "Biological Annihilation via the Ongoing Sixth Mass Extinction Signaled by Vertebrate Population Losses and Declines," *Proceedings of the National Academy of Sciences of the United States of America* 114, no. 30 (July 25, 2017), https://doi.org/10.1073/pnas.1704949114.

John Martin

English, 1789–1854
Country of the Iguanodon, from
Gideon Mantell's *Wonders of
Geology*, vol. 1, 1838
Steel mezzotint engraving
7 x 4¾ x 1¼ in.
Courtesy of Linda Hall Library
of Science, Engineering, and
Technology, Kansas City,
Missouri

John Martin's fantastic scene of a *Megalosaurus* attacking an *Iguanodon* was published as the frontispiece for Gideon Mantell's book *Wonders of Geology.* The artist hypothesized the reconstruction of the *Iguanodon* after studying only a few fossil bones, teeth, and horn in the author's collection.

Martin placed his lizard-like creatures in their tropical habitat of palms, cycads, and tree ferns, recreating the landscape that defined Sussex, England, over a hundred million years ago. The awesome subject of *Country of the Iguanodon* appealed to the much-admired artist, who specialized in painting sublime landscapes with epic biblical themes.

Mantell's *Wonders of Geology* and the public display of fossils in his home helped stimulate the English enthusiasm for beastly creatures. The *Megalosaurus* and the *Iguanodon,* the first known dinosaurs, were also interpreted by Benjamin Waterhouse Hawkins in life-sized, concrete sculptures. Dating from 1854, they were exhibited in Sydenham Park outside London to accompany the great exhibition hall of the Crystal Palace. In 2002, the world's first dinosaur sculptures were restored in all their inaccurate anatomical glory.

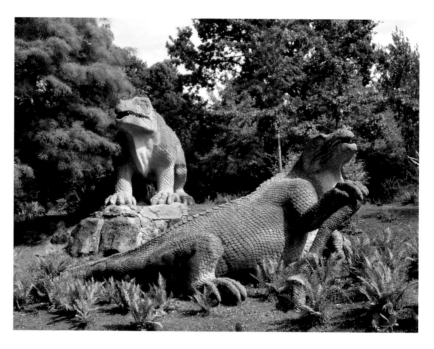

BENJAMIN WATERHOUSE HAWKINS, *Iguanodons,* 1854,
Crystal Palace Park, London; photo by Ian Wright.

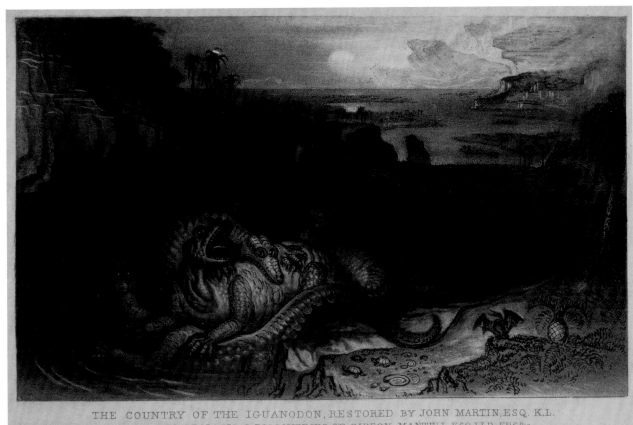

THE COUNTRY OF THE IGUANODON, RESTORED BY JOHN MARTIN, ESQ. K.L.
FROM THE GEOLOGICAL DISCOVERIES OF GIDEON MANTELL, ESQ. LL.D., F.R.S.&c.

Édouard Riou

French, 1833–1900
Apparition de l'Homme
(*Appearance of Man*) from Louis
Figuier's *Terre avant le Déluge*
(*The World before the Deluge*), 1866
Engraving
9½ x 6¾ x 1⅜ in.
Courtesy of Linda Hall Library
of Science, Engineering, and
Technology, Kansas City,
Missouri

Édouard Riou's *Appearance of Man*, featured in Louis Figuier's best-selling book *Earth Before the Deluge*, was one of the first images of prehistoric humans living alongside now-extinct species such as mammoths and cave bears. It was one of twenty-five primeval landscapes illustrating the life of past geological ages, which the author believed was swept away by the biblical flood depicted in the book's final image.

Louis Figuier (1819–1894) was a physician and chemist whose books, ranging in subject matter from oceans to insects, made science accessible to a general audience. *The World before the Deluge*, his most widely read work, attempted to reconcile rapidly emerging scientific evidence of Earth's evolution with the Judeo-Christian tradition.

When the book was first published, in 1863, Riou presented a more pastoral view of humans living in an Edenic setting with cows, sheep, and deer. For this 1866 edition, the artist radically transformed his original biblical family into a clan of hunters and gatherers wielding stone weaponry.

Where man and woman fit into the timeline of Earth's history changed dramatically, after proof of human interactions with extinct animals was discovered. In 1864 archaeologists uncovered, from a rock shelter in France, a section of ivory carved with an image of a living mammoth. Named *The Mammoth of La Madeleine*, its artistry attested to the sophistication of Ice Age humanity. Riou's illustration was directly influenced by this extraordinary find.

Riou studied with Gustav Doré (1832–1883), a popular graphic artist known for his romantic landscapes and dramatic use of light and shade. Following in his mentor's footsteps and riveted by new scientific ideas, Riou illustrated many of Jules Verne's classic books, including *Voyage to the Center of the Earth* (1864).

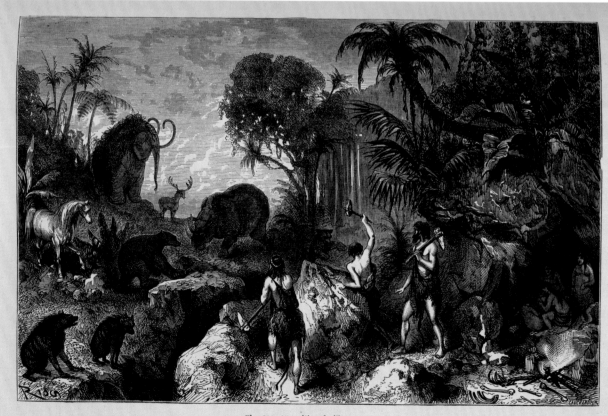

Fig. 323. Apparition de l'homme.

David W. Miller

American, b. 1957
Quetzalcoatlus, 2002
Oil and acrylic on illustration
board
16 x 12 in.
Courtesy of the New York State
Museum, Albany

Quetzalcoatlus, the largest flying animal to have ever lived, comes alive in David Miller's striking composition depicted from a low vantage point. The artist conveys the immense size of this creature, whose wingspan measured close to forty feet, by comparing it to the towering trees of a North American forest dating one hundred million years ago.

The artist continues the tradition, established by Charles Knight, of reconstructing prehistoric animals and landscapes for exhibition at natural history museums. Collaborating with paleontologists who provide guidance on anatomy and musculature, Miller draws preliminary sketches for his final paintings on permanent display at museums around the country.

The artist's work, representing a diverse range of primeval animals, are in the collections of the Smithsonian Institution, the American Museum of Natural History, and Yale University's Peabody Museum. A solo exhibition, *Scary Fishes from Deep Time*, was shown at the University of Washington's Burke Museum in 2000, following his contribution to the acclaimed book *Discovering Fossil Fishes* by John G. Maisey. In 2004, *Quetzalcoatlus* was exhibited in *Paleo Art* at the Denver Museum of Nature and Science.

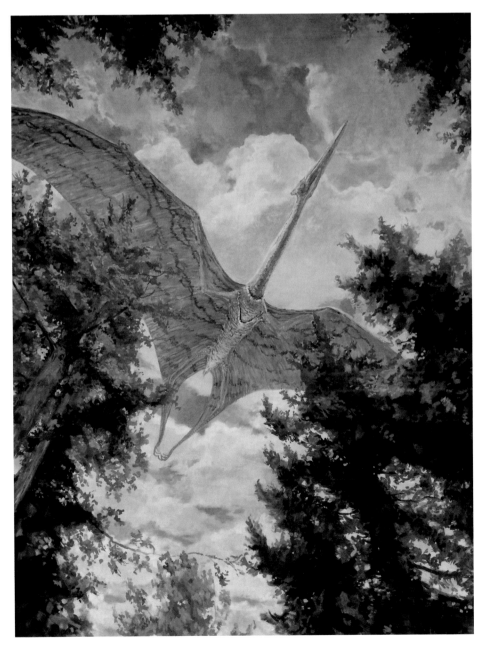

Charles R. Knight

American, 1874–1953
Woolly Mammoth and Hunter,
1909
Oil on canvas
27½ x 39½ in.
Courtesy of the American
Museum of Natural History,
New York

Charles Knight was one of the first artists to paint panoramic murals of extinct animals in their prehistoric habitat for natural history museums. His *Woolly Mammoth and Hunter* foreshadows a fifty-foot-long painting of a mammoth herd dated 1916, the first of a series that remains on display in New York's American Museum of Natural History.

Most woolly mammoths survived until the end of the Ice Age, an epoch called the Pleistocene that began 2.5 million years ago. The grasslands where these animals grazed eventually succumbed to dense forests. Loss of habitat, likely exacerbated by human hunting, precipitated the mammoth's extinction.

Knight worked with Henry Fairfield Osborn, a paleontologist and curator at the American Museum of Natural History, to assemble fossilized bones of extinct creatures into life-like poses for exhibition. He made models of the skeletons and added clay muscles and skin using his knowledge of contemporary animal anatomy.

A dual passion for the world of living fauna inspired the artist to draw zoo animals and study the bronze sculptures of Antoine-Louis Barye, whose *Wolf Holding a Stag by the Throat* is illustrated on page 56. Knight's sculptural models informed his watercolors and paintings commissioned by the museum. He eventually cast some of these sculptures, including a woolly mammoth, into bronze.

During a period of feverish interpretation of fossil treasures excavated from the American West, Knight also painted murals for the Natural History Museum in Los Angeles and Chicago's Field Museum of Natural History. The artist authored and illustrated volumes about prehistoric biodiversity, as well as a how-to book titled *Animal Drawing: Anatomy and Action for Artists* (1947). Images by Knight that appeared in magazines such as *National Geographic* in 1942 further disseminated knowledge of Earth's lost worlds during the first half of the twentieth century.

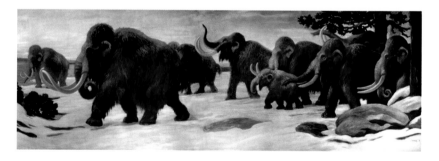

CHARLES KNIGHT, detail from mural of *Woolly Mammoths and Reindeer near Somme River, France,* 1916, oil on canvas, American Museum of Natural History.

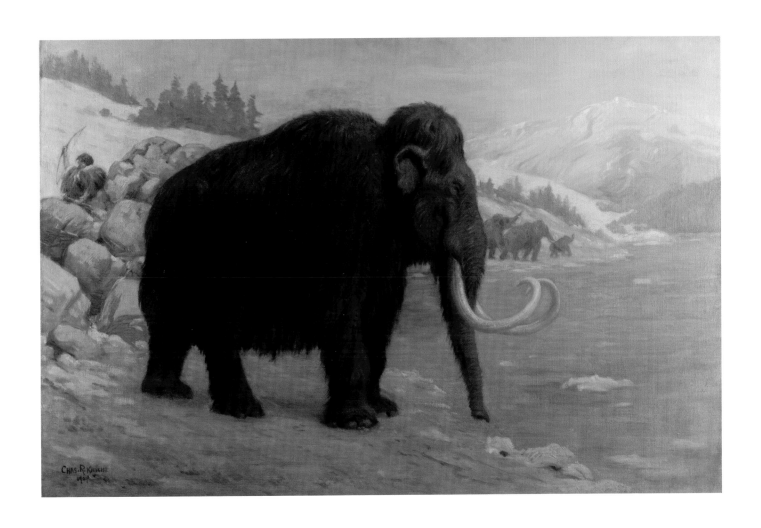

PORTRAITS OF LOSS
Extinction by Human Actions

How can you expect the birds to sing when the groves are cut down?

—HENRY DAVID THOREAU, *Walden; or, Life in the Woods*, 1854

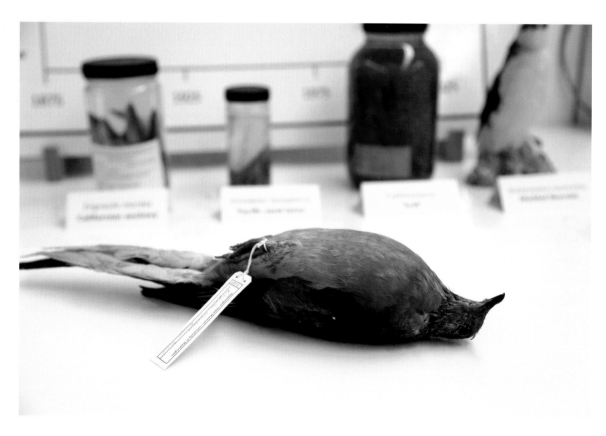

Passenger pigeon, Burke Museum of Natural
History and Culture, catalog no.UWBM 6878.
Artists often study museum specimens in collections
storage to inspire and guide their work.

In contrast to the natural events that triggered Earth's five mass extinctions, human activities are now responsible for the greatest loss of biodiversity since the age of dinosaurs. Biologists estimate that 50 percent of all plants and animals will vanish before the end of this century.[1] How can we grasp the significance of this loss? We turn to the work of artists, who have an extraordinary capacity to touch us in ways that facts and figures cannot.

Artists transform scientific documentation about early human-induced extinctions—the dodo, the great auk, and the passenger pigeon, among others—into stirring portraits and still lifes. They commemorate animals and plants snuffed out by our own species to spark awareness about the contemporary extinction crisis. Their artworks reflect meticulous research and observational analysis of specimens from natural history museum collections. Sometimes they draw inspiration from nothing but pathetic remains. By reviving past life in often startling ways, these artists imprint their memory on our consciousness.

Since the first *Homo sapiens* migrated out of Africa one hundred thousand years ago, three waves of human-induced extinctions have been identified. Each surge increased in scope and intensity. The loss of life at these major junctions in time spurred new rituals and forms of art to spiritually compensate for the traumatic harm inflicted on other species.

Early hunters and gatherers began transforming habitats and stressing plants and animals as they fanned out across the continents. They used fire to clear forests and attract animal prey favoring mixed woods and grassland habitats. To maintain stable populations of herds, cave paintings may have communicated concepts of fertility, balance, and a hunting ethic to protect the female of the species.

The second extinction wave marked the advent of agriculture around twelve thousand years ago. In separate locations around the world, intensive farming and animal domestication resulted in deforestation and human population explosions. Artists responded by introducing the symbol of the sacred tree, which appears in the ancient cultures of Mesopotamia, Egypt, India, and Mesoamerica. This imagery corresponded to the creation of groves for worship that helped to protect forests.

The third and largest extinction wave coincided with the Industrial Revolution's rampant pollution and accelerated forest loss in Europe and North America.

At that moment, the Romantic Movement emerged in literature and art to reaffirm the sublimity of nature.

For the first time in the history of Western art, landscape painting became the preeminent genre and defined the course of nineteenth-century art. Artists catered to wealthy urban patrons who coveted images of natural scenery. Paintings and photographs of majestic landscapes also helped catalyze the creation of national parks and activate the conservation movement.

World War II ushered in the growth of the nuclear and petrochemical industries, whose pollution has spread around the world. The consequences of industrial toxins have impacted wildlife populations, which have declined by 52 percent in the brief period between 1970 and 2010.[2]

Now, for the first time in Earth's history, *Homo sapiens* have severely transformed all aspects of the natural world, including the climate. The term "Anthropocene" has been coined to mark the dawning of this new era of humanity's pervasive impact on the planet.

As in the past, an intensifying crisis now challenges artists to communicate the shocking loss of life and ecosystems. Their creative interpretations of significant historical, human-induced extinctions contribute to an evolving public consciousness supporting biodiversity. Artists ultimately hope to galvanize mindfulness of an individual's environmental footprint and garner support for global conservation efforts currently underway.

NOTES

1 Geraldo Ceballos, Paul R. Ehrlich, and Rodolfo Dirzo, "Biological Annihilation via the Ongoing Sixth Mass Extinction Signaled by Vertebrate Population Losses and Declines," *Proceedings of the National Academy of Sciences of the United States of America* 114, no. 30 (July 25), 2017, https://doi.org/10.1073/pnas.1704949114.

2 Statistic cited in the *Living Planet Report 2014*, published by the World Wildlife Fund and the Zoological Society of London, 2014. The publication was summarized by Damian Carrington in "Earth Has Lost Half of its Wildlife in the Past Forty Years, Says WWF," *Guardian*, September 30, 2014, https://www.theguardian.com/environment/2014/sep/29/earth-lost-50-wildlife-in-40-years-wwf.

John James Audubon

American, 1785–1851
The Great Auk, from *Birds of
America*, vol. 7, plate 465; 1844
Hand-colored lithograph
10⅜ x 7 x 2⅛ in.
Courtesy Linda Hall Library
of Science, Engineering, and
Technology, Kansas City,
Missouri

In this illustration of a species on the brink of extinction, John James Audubon composes a majestic portrait of a great auk off the rugged Newfoundland coast. The artist's signature achievement of sensitively rendering the relationship between birds and their habitats set the standard for future generations of wildlife painters. It is noteworthy that Audubon did not paint birds on the spot, but rather hunted and posed them in his studio-cum-natural history museum.

A self-taught artist and natural scientist, Audubon began drawing every known bird in the United States in 1820. By the end of his eighteen-year project, he had painted 435 life-sized watercolors that were engraved or lithographed and hand-colored for publication. The popularity of his book *Birds of America* resulted in many editions, including the original giant double elephant folio (1826-1838) and the smaller royal octavo edition (1840-1844) seen here.

Humans hunted the great auk, which once ranged across the North Atlantic, for their down feathers stuffed in pillows. The rising demand for down, food, and fishing bait set the stage for their extinction. The rarity of the great auk incited a frenzy for their eggs and taxidermy specimens among collectors and museums. This delivered the species its final blow in 1844.

Many bird species painted by Audubon are currently endangered, threatened, or in decline. The Audubon Society claimed the artist's name in 1905 and became one of America's leading conservation organizations protecting birds and their ecosystems.

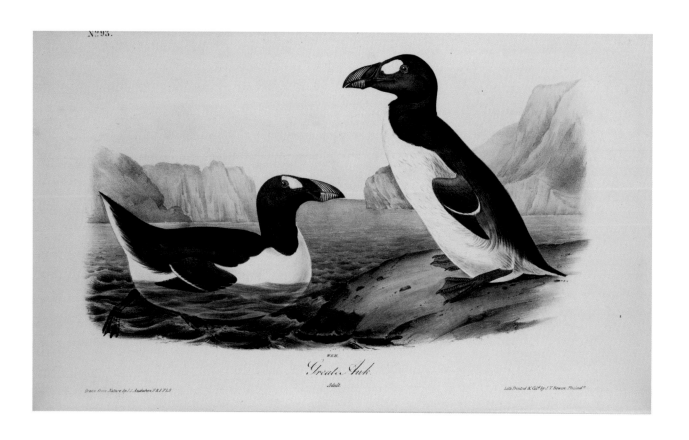

Great Auk.

Christy Rupp

American, b. 1949
Great Auk, from *Extinct Birds
Previously Consumed by Humans,*
2005–2008
Steel, chicken bones, mixed
media
30 x 17 x 21½ in.
Courtesy of the artist

The work is less about extinct species and more concerned
with how we treat animals that still exist.
—Christy Rupp

Christy Rupp constructed *Great Auk* from bones of industrially raised
chickens marketed in fast-food restaurants and supermarkets. This sculp-
ture, along with twelve other life-sized resurrected skeletons, commemo-
rates birds decimated by human consumption. Rupp began her series
after an avian flu scare in 2005 that resulted in the slaughter of millions
of animals who may have carried a virus.

Intense observation defined Rupp's process of measuring and pho-
tographing preserved specimens at New York's American Museum of
Natural History. She consulted the museum's ornithologist as well as 3-D
models on university department websites, which helped her determine
how to pivot the sculptures in space. Although the artist attempted to
make the best reconstruction, her work underlines "the fact that a human
cannot recreate or fix nature."

While referencing the past butchery of species by humans, Rupp
writes about the current health issues associated with eating mass-
produced birds grown rapidly with hormones and antibiotics. She also
calls attention to the waste generated by factory farms in the form of
land, water, and air pollution.

Harri Kallio

American, b. Finland, 1970
Les Gris Gris #3, Mauritius, from
The Dodo and Mauritius Island,
Imaginary Encounters, 2004
Archival inkjet print
29½ x 36 in.
Courtesy of the artist

The large, flightless dodo bird intrigued Harri Kallio while reading Lewis Carroll's *Alice's Adventures in Wonderland* (1865). He was particularly drawn to an illustration by John Tenniel, who prominently portrayed the dodo alongside the book's heroine. Tenniel, in turn, was captivated by a portrait of the bird painted by the seventeenth-century Dutch artist Roelant Savery.

Kallio created two life-sized dodo sculptures based on these earlier artistic interpretations and the meager skeletal remains that exist. He then strategically sited his reconstructions in the dodo's native habitat on Mauritius Island, located twelve hundred miles off the African coast in the Indian Ocean. He produced a series of photographs and wrote a fascinating history of the dodo that resulted in an award-winning book, *The Dodo and Mauritius Island: Imaginary Encounters* (2004).

Now recognized as the largest member of the pigeon family, the dodo became extinct eighty-three years after Dutch sailors landed on Mauritius Island in 1598. Although eaten by sailors who clubbed the birds to death, the dodo's demise has been linked to the invasive species—rats, pigs, and monkeys—transported on ships. These exotic animals ate the dodo's eggs, trampled its environment, and outcompeted the bird for food.

In *Les Gris Gris #3,* named after the geographic locale of this photograph, Kallio resurrects a lost world of helpless birds that could not fly away to safety. The artist's imaginary encounters with the dodo poignantly evokes potential scenarios facing endangered species today.

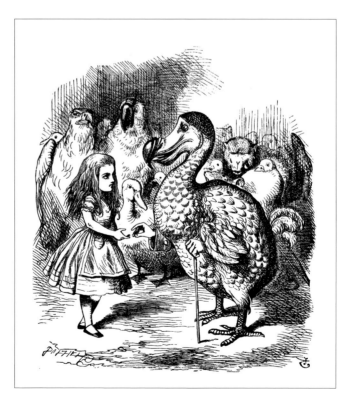

JOHN TENNIEL, *A Caucus-Race and a Long Tale,*
illustration from Lewis Carroll's *Alice's Adventures in*
Wonderland, 1865.

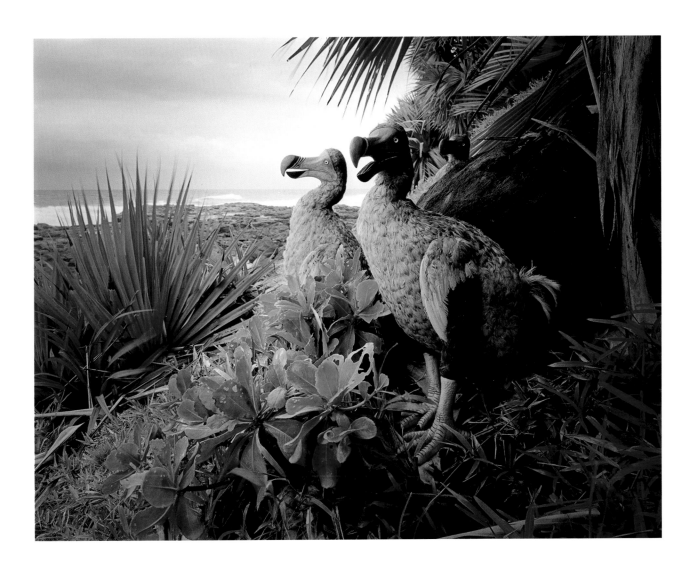

John James Audubon

American, 1785–1851
Passenger Pigeon, from *Birds of America*, vol. 5, plate 285; 1842
Hand-colored lithograph
10⅜ x 7 x 2⅛ in.
Courtesy of Linda Hall Library of Science, Engineering, and Technology, Kansas City, Missouri

Here again, the tyrant of the creation, man, interferes, disturbing the harmony of this peaceful scene. As the young birds grow up, their enemies, armed with axes, reach the spot, to seize and destroy all they can. The trees are felled, and made to fall in such a way that the cutting of one causes the overthrow of another, or shakes the neighbouring trees so much, that the young Pigeons, or squabs, as they are named, are violently hurried to the ground. In this manner also, immense quantities are destroyed.

—John James Audubon

John James Audubon portrayed his passenger pigeons during "the love season," tenderly mating in a posture called "billing." In his *Birds of America*, this illustration was accompanied by a grim description of how the reproduction and raising of chicks were disrupted by human violence.

The artist also lamented the loss of Eastern forests that he knew would affect the viability of the passenger pigeon population. Fast, graceful, and traveling up to sixty miles per hour, the birds fed mainly on acorns, chestnuts, and beech nuts in the extensive woodlands of North America. As the trees were steadily logged, passenger pigeons lost their habitat and food supply. The passenger pigeon met its final demise almost seventy-five years after Audubon interpreted a breeding pair in *Birds of America*.

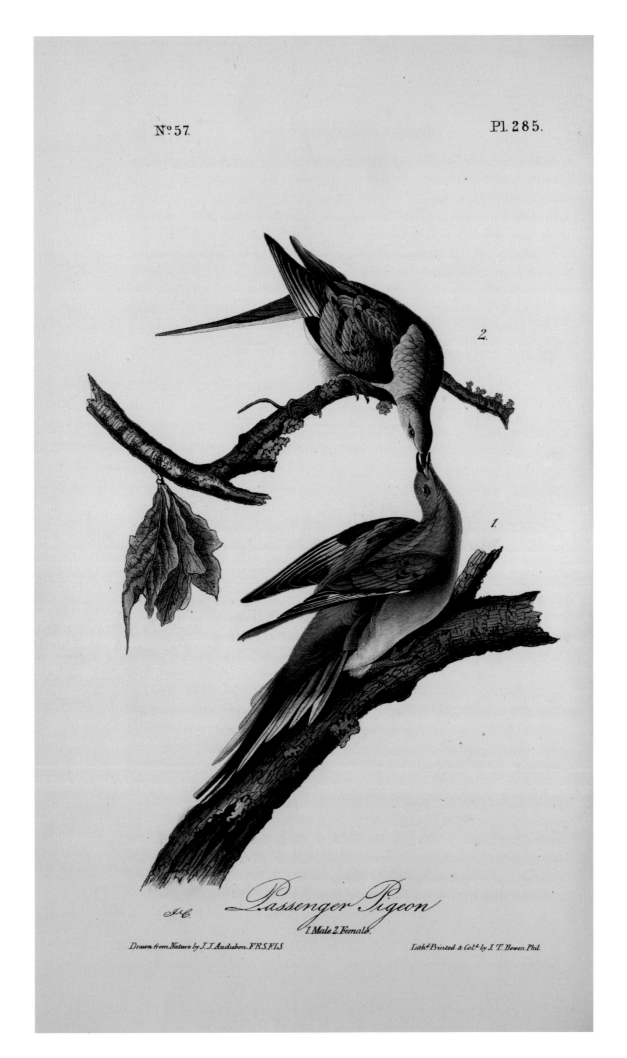

Passenger Pigeon
1. Male 2. Female.

Drawn from Nature by J.J. Audubon, F.R.S. F.L.S.

Lith.ᵈ Printed & Col.ᵈ by J. T. Bowen Phil.

Sara Angelucci

Canadian, b. 1962
*Aviary (Female and Male
Passenger Pigeons/extinct)*, 2013
C-prints
38 x 26 in.
Courtesy of artist

And, what would it mean to embody another creature:
Could one then see, feel, and understand its desire to live?

—Sara Angelucci

The extinct passenger pigeon comes back to haunt us in these formal portraits of intriguing, human-bird creatures. Sara Angelucci morphs photographs of taxidermy specimens and images from vintage visiting cards that were popular in the nineteenth century. Both are "ghosts of the past." By merging the identities of people and bird, the artist evokes a sense of empathy with this lost species.

These photographs belong to *Aviary*, a series on endangered and extinct North American birds created by Angelucci during a 2013–2014 residency at the Art Gallery of Ontario. In conjunction with her museum installation, the artist conceived and produced an unusual, multi-person choral performance inspired by bird calls.

The death of the last passenger pigeon living in the Cincinnati Zoo marked the species' extinction in 1914. Numbering in the billions, these birds migrated across the North American continent in miles-long flocks in search of food. In less than a century, the most abundant bird on Earth was destroyed by the large-scale, unregulated commercial hunting of cheap meat for urban dwellers. Angelucci's photographs resurrect the saga of the passenger pigeon to reinforce the message of common-sense stewardship of life.

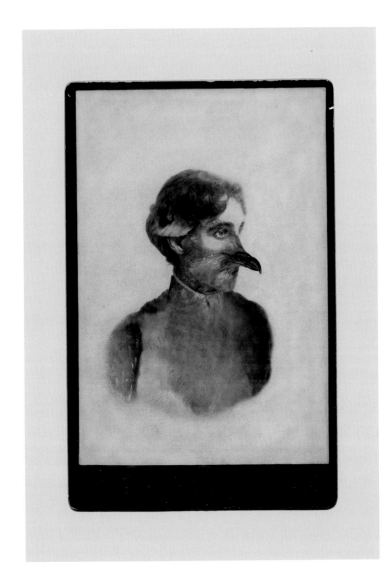
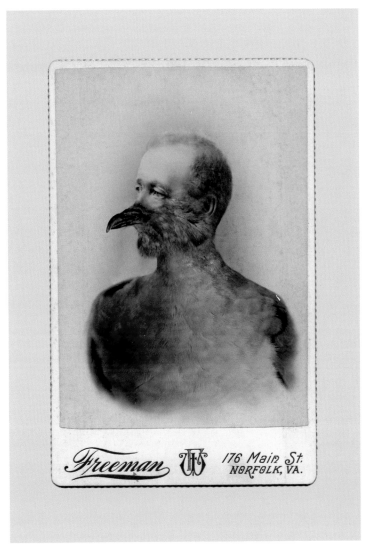

Isabella Kirkland

American, b. 1954
Gone, from the *Taxa* series, 2004
Oil and alkyd on canvas over panel
48 x 36 in.
Private Collection

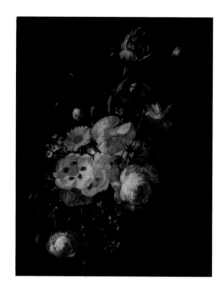

RACHEL RUYSCH, *Still Life with Flowers in a Glass Jar*, oil on canvas, 25½ x 13¾ in. Collection of the Rijksmuseum, Amsterdam.

In the *Taxa* series, almost every plant or animal is measured, photographed, drawn, and observed first hand from preserved materials. All are painted at life-size to ensure accuracy of scale.... The paintings explore how current biodiversity science can inform art-making and how art objects contribute to both political and scientific dialogues.

—Isabella Kirkland

Gone is one of six paintings by Isabella Kirkland in a series that portrays nearly four hundred species of plants and animals. During many years of extensive research, the artist visited natural history museums around the world to study and document specimens.

In this still life of human-made extinction, Kirkland interprets sixty-three species that have vanished since the eighteenth century. Noteworthy is the painter's attention to plants, which are often neglected by both artists and scientists concerned with the extinction crisis.[1] As in many nineteenth-century depictions by artist-scientists, *Gone* is accompanied by a numbered species identification guide.

Kirkland updates the seventeenth-century Dutch still life tradition wherein abundant displays of life symbolized Holland's rising wealth and maritime influence. While honoring artists such as Rachel Ruysch (1664–1750), Kirkland indirectly connects extinct species with the cascading effects of early European exploration, exploitation of nature, and commerce.

Another painting in Kirkland's *Taxa* series, *Descendent,* was featured on the cover of E.O. Wilson's book, *The Future of Life* (2002). Once the only female taxidermist in New York City, the artist works as a research associate at the California Academy of Sciences.

NOTES

1 Some of the reasons why are explained by botanists Stefano Mancuso and Alessandra Viola in their book, *Brilliant Green: The Surprising History and Science of Plant Intelligence* (Washington, DC: Island Press, 2015).

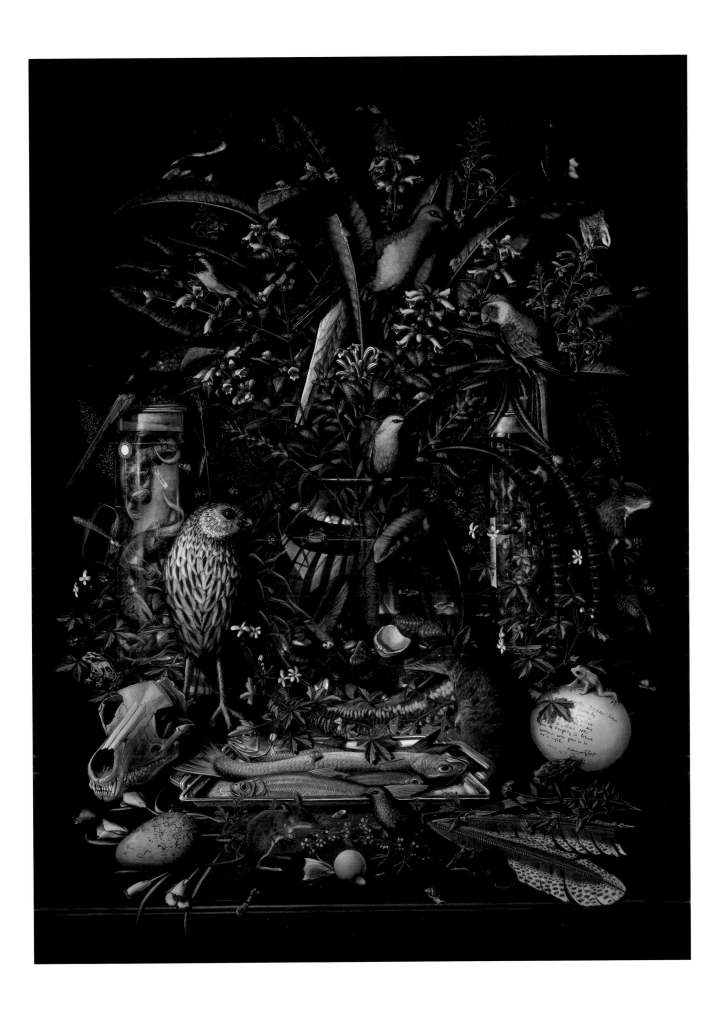

ENDANGERED SPECIES
Plants and Animals on the Edge of Survival

Every seed is awakened and so has all animal life.

It is through this mysterious power that we too have our being

And we therefore yield to our neighbors,

Even our animal neighbors,

The same right as ourselves, to inhabit this land.

—Attributed to **SITTING BULL** (Tȟatȟáŋka Íyotake), Hunkpapa Lakota

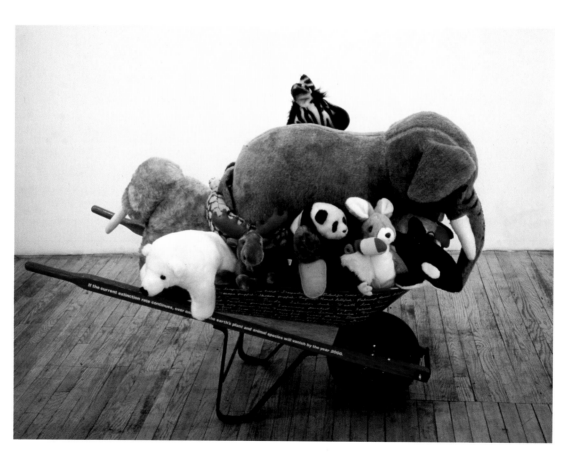

MARK DION, *Survival of the Cutest (Who gets on the Ark?),* from *Wheelbarrows of Progress,* with William Shefferine, 1990; toy stuffed animals, white enamel on red steel, wood, and rubber wheelbarrow. Courtesy of the artist and Tanya Bonakdar Gallery, New York.

One step away from extinction, the plants and animals interpreted by artists here have come to symbolize the threatened ecosystems in which they live and the global dimension of declining biodiversity. The artworks call attention to just a few of the ten thousand endangered and critically endangered species classified by the International Union for the Conservation of Nature.

Nineteenth-century artists John James Audubon and George Catlin were among the earliest Americans to lament the loss of animals and their habitats. They catalogued biodiversity and documented species in danger of extinction, including the American bison, as the nations of North America expanded their continental footprints. The loss of the bison, a keystone species for ensuring a healthy ecosystem, was calamitous to Native Americans and the grasslands of the Great Plains. Its near extermination by 1898 was a wake-up call that bolstered the conservation movement.[1]

During Theodore Roosevelt's tenure as president of the United States, conservation became a domestic priority. Between 1901 and 1909, 150 national forests, 53 federal wildlife preserves, 5 national parks, and 18 national monuments encompassing 230 million acres of public land were created.

A second groundswell of environmental activism, generated by concerned citizens, ushered in significant legislation to protect land, water, and wildlife during the 1960s and 1970s. The landmark US Endangered Species Act of 1973, supported by both political parties and signed into law by President Richard Nixon, has reduced the loss of biodiversity by providing for the conservation of plants, animals, and the ecosystems upon which they depend. Approximately 2,300 species are currently listed as endangered or threatened under the Endangered Species Act.

Since the 1980s, artists' concerns about the loss of biodiversity have coalesced around a multiplicity of media and styles that mirror the diversity of species at risk. Drawing from scientific naturalism, conservation photography, Pop art, Surrealism, and Formline art, among others, artists create works that garner empathy and command attention. They provocatively confront the extinction crisis that was merely intuited in nineteenth-century art.

Works by today's artists assume ever greater importance as the current federal government begins to dismantle more than a century of legislation protecting life and land. To counter these draconian actions and advance the timeline of conservation milestones, artists offer a unique form of communication that taps into the core of human culture—beauty and emotion. Inspired by the natural world, art has shaped the vision of *Homo sapiens* and defined the species from its beginnings.

As image makers and conceptual visionaries, artists have the capacity to heighten public awareness about the current condition of life and environmental distress. Historically, this knowledge has strengthened the conservation ethic and ultimately secured greater environmental protection. The future of life, including our own species, continues to depend on humanity's compassionate values and savvy actions.

NOTES

1 The decimation of the American bison coincided with the extermination of the passenger pigeon. Both witnessed catastrophic declines between 1860 and 1880. The American bison was nurtured back to viability as a species while the passenger pigeon perished.

George Catlin

American, 1796–1872
Buffalo Bull, Grazing on the Prairie, 1832–1833
Oil on canvas
24 x 29 in.
Smithsonian American Art Museum, Gift of Mrs. Joseph Harrison Jr.

In this unusual portrait, George Catlin separates a lone buffalo from its herd to establish a direct connection with the viewer.[1] Through its piercing gaze, the bull both startles us and demands recognition of his existence. This painting was created the same year that Catlin prophesied the extinction of the buffalo and called for the creation of a national park to protect "both man and beast, in all the wild and freshness of nature's beauty!"

In the 1830s, Catlin followed partway in the footsteps of the Lewis and Clark Expedition. He documented the indigenous cultures of the Great Plains that depended on the American bison for survival. By 1889, the estimated fifty million bison that once thrived on the continent were gone, slaughtered for sport, leather hides, and fertilizer ground up from its sculls.

Ten thousand bison were rescued and nurtured to create new Western herds. The efforts were spearheaded in part by the American Bison Society, which was founded in 1905 by President Theodore Roosevelt and William T. Hornaday, chief taxidermist at the Smithsonian Institution.

This largest North American mammal is currently listed as near threatened, according to the International Union for the Conservation of Nature. Fewer than thirty thousand animals are in conservation herds and fewer than five thousand are unfenced and disease free. The American bison's ultimate survival portends a cautionary saga for today.

Efforts to bolster the species continue through the work of the Intertribal Buffalo Council. Collaborating with conservation organizations, the council increases the size of herds and supports educational programs that reinforce the bison's role in Native American culture. In contrast to the ominous future predicted by George Catlin, the prospects for both indigenous peoples and the bison will remain strong as long as respect for human rights, the environment, and this awesome creature is vigilantly enforced.

NOTES

1 Although popularly called a buffalo, North America's largest mammal is scientifically known as an American bison (*Bison bison*).

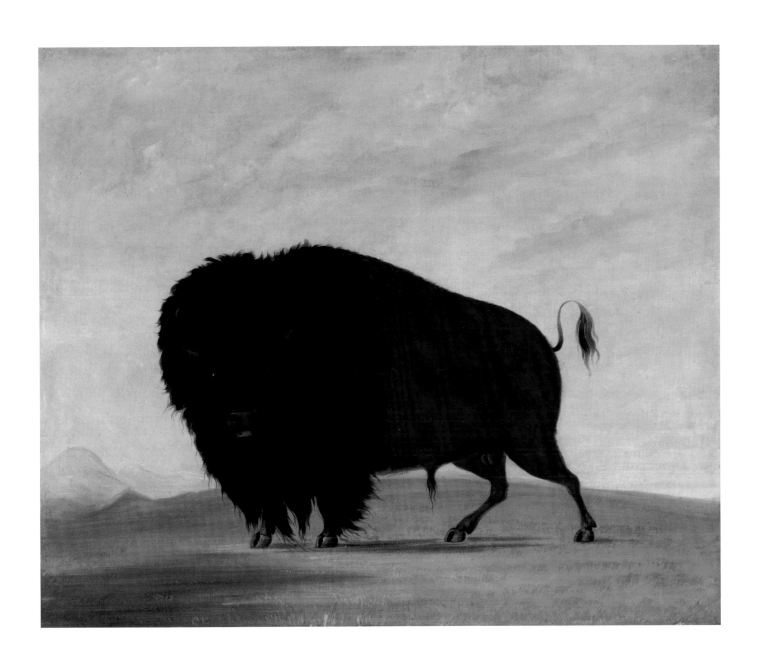

Antoine-Louis Barye

French, 1796–1875
Wolf Holding a Stag by the Throat, modeled 1843 (cast date unknown)
Bronze
15¼ x 5½ x 8½ in.
Whatcom Museum, Gift of Julie Ward, 1991.2.1

Antoine-Louis Barye captures the climactic moment of combat between a wolf and a mighty male deer. Although small in scale, the sculpture's epic composition and realistic details reveal the artist's discerning powers of observation. Barye, hailed as the most celebrated animal sculptor of his time, mastered anatomy by sketching exotic mammals in a Paris zoo. He later became professor of drawing at the city's internationally renowned National Museum of Natural History.

During the nineteenth century, non-domesticated animals were popularly represented in Europe and North America as ferocious creatures engaged in continuous battle with their prey. The wolf, in particular, appealed to humanity's primal fear of beasts, reinforced by tall tales such as *Little Red Riding Hood*, which dates back one thousand years.

Although humans are no longer directly threatened by wolves, the negative culture surrounding the species survives in its merciless killing at every opportunity. The complicated relationship between wolves and people has resulted in their on-again, off-again listing as an endangered species. In 2017, federal protection for the wolf was eliminated.

The gray wolf is a keystone species whose presence benefits all aspects of the environment. The animal's critical role in maintaining a balanced ecosystem is illuminated by Chris and Dawn Agnos in their video *How Wolves Change Rivers*, the remarkable story of the animal's reintroduction into Yellowstone National Park.

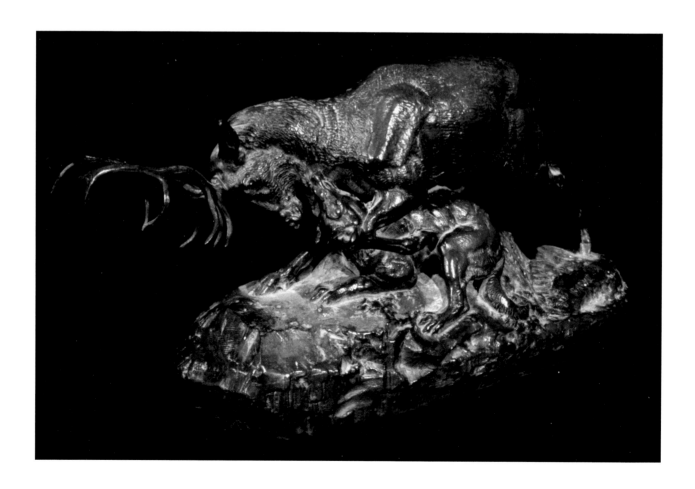

Nicholas Galanin

Tlinget-Aleut, b. 1979
Inert Wolf, 2009
Wolf pelts and felt
74 x 65 x 24 in.
Courtesy of the Burke Museum
of Natural History and Culture,
catalogue number 2012-83/1

I look at this piece in cultural terms. Mainstream society often looks at Indigenous or Native American art through a romantic lens, not allowing a culture like my Tlingit community room for creative sovereign growth. The back half of this piece is contained, a captured trophy or rug to bring into the home, while the front continues to move. It is sad and the struggle is evident.

—Nicholas Galanin

Part trophy rug and part struggling to survive, *Inert Wolf* demands viewer empathy with a much-maligned creature. The riveting presence of this taxidermy sculpture, made from two wolf pelts joined together, offers a study in contrasts with Antoine-Louis Barye's *Wolf Holding a Stag by the Throat*.

Nicholas Galanin writes about this work from the perspective of his native ancestry, focusing on loss of habitat from sprawling development that impacts both his people and wolves. Northwest Coast clans revere the wolf and bond with the animal in sacred ceremonies. Woven into family identities, its image often appears on masks and totem poles. The extermination of the wolf, as with the American bison, becomes emblematic of the suppression of vibrant indigenous cultures.

Nearly eliminated from the contiguous United States by the mid-1950s through habitat destruction and government rewards, the gray wolf was reintroduced into a few states beginning in 1995. Biologists estimate 5,500 wolves remain, with populations in Montana, Wyoming, Idaho, Minnesota, Wisconsin, and Michigan. A few packs also roam Oregon, Washington, and California. The historic population in these regions has been estimated at four hundred thousand. Human threats to wolf survival remain significant without the protections guaranteed by the Endangered Species Act, which were first granted in the 1970s and recently stripped away.

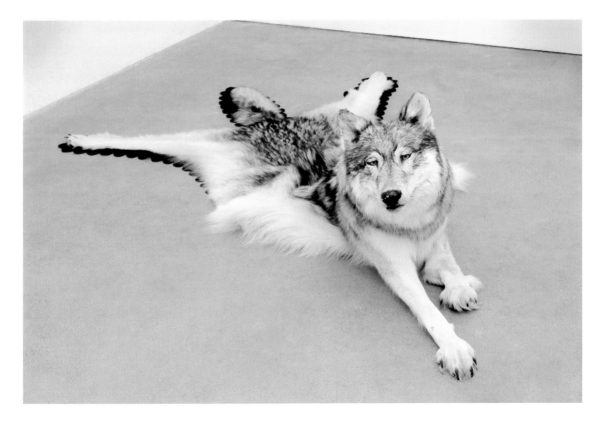

Andy Warhol

American, 1928–1987
Endangered Species, 1983
10 silkscreen prints
38 x 38 in.
© 2018 The Andy Warhol
Foundation for the Visual Arts
/ Artists Rights Society (ARS),
New York / Ronald Feldman
Fine Arts, New York

Andy Warhol, known for his love of animals, portrayed endangered species from around the world in 1983. His historic screen prints were among the first interpretations of endangered wildlife by a prominent contemporary artist. Warhol described how he boldly colored the "animals in make-up" to stylishly resemble his celebrity portraits. With his Pop art flair, the artist endowed these creatures with movie star auras that call attention to their vulnerable status.

All the fauna, except the bald eagle and the Pine Barrens tree frog, remain on the Endangered Species Act list. One hundred prints in this series, commissioned by philanthropic gallerists Ronald and Frayda Feldman, were donated to conservation organizations for their auction fundraisers.

In 1986, Warhol interpreted fifteen more species for the book *Vanishing Animals*. Art and science coalesced in his collaboration with Dr. Kurt Benirschke, who wrote the text and established the San Diego Zoo's Center for the Reproduction of Endangered Species. Warhol's life was cut short a year after the book's publication; one can only wonder whether his conservation efforts would have continued.

THIS PAGE, LEFT TO RIGHT/TOP TO BOTTOM

Siberian Tiger (Leo tigris altaica)
Pine Barrens Tree Frog (Hyla andersonii)
Bighorn Ram (Ovis canadensis)
Black Rhinoceros (Diceros bicornis)

OPPOSITE PAGE, LEFT TO RIGHT/TOP TO BOTTOM

African Elephant (Loxodonta africana)
Giant Panda (Ailuropoda melanoleuca)
Bald Eagle (Haliaeetus leucocephalus)
San Francisco Silverspot (Speyeria callippe callippe)
Orangutan (Pongo pygmaeus)
Grevy's Zebra (Equus grevyi)

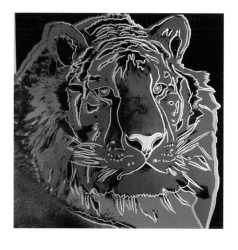
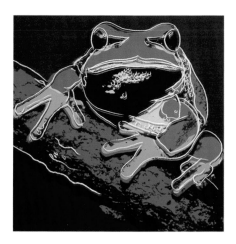
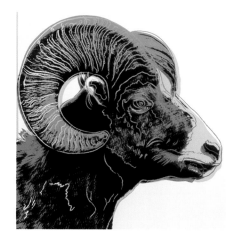
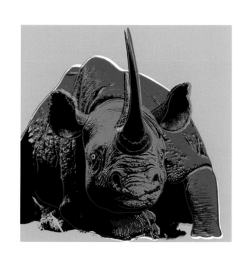

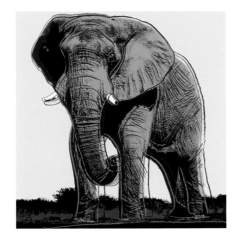
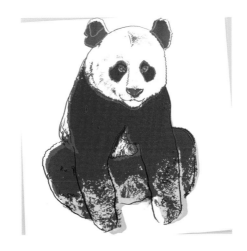
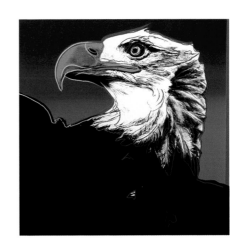
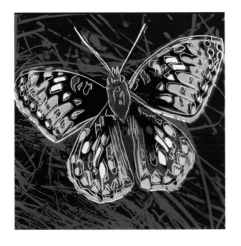
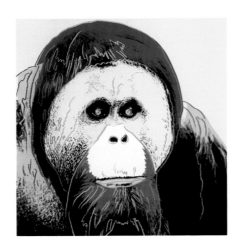
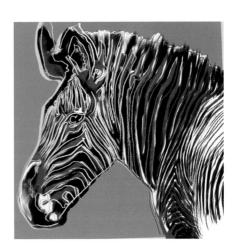

Madeline von Foerster

American, b. 1973
Carnival Insectivora (Cabinet for Cornell and Haeckel), 2013
Oil and egg tempera on panel
20 x 16 in.
Collection of John Brusger

But on a deeper level, my paintings are visual altars
for our imperiled natural world.

—Madeline von Foerster

Among the few artists to convey the fate of endangered flora, Madeline von Foerster paints a still life of carnivorous plants using a five-hundred-year-old Flemish Renaissance technique that accentuates exquisite details and colors. The artist pays homage to the artist-biologist Ernst Haeckel and his influential drawings of flora and fauna in his book *Art Forms of Nature* (1904). The work also references Joseph Cornell's dream-like sculptural boxes, which are similarly intimate in scale.

Carnivorous plants survive in low-nutrient bogs by trapping and digesting insects. These swamp-like environments are often drained and developed for residential and agricultural use. The Venus flytrap now survives in the wild within a seventy-five-mile area in North Carolina. Threatened due to habitat destruction and rampant poaching of wild species, it is currently listed as a species of concern, a status that offers no legal protection. In 2016, a group of botanists petitioned for Endangered Species Act listing, which would provide the plants a chance to survive.

In *Carnival Insectivora*, von Foerster includes human hands lovingly safeguarding a vessel of imperiled plants. Offering this bouquet to the viewer, the artist affirms the beauty and vitality of an extraordinary group of plants whose future we hold.

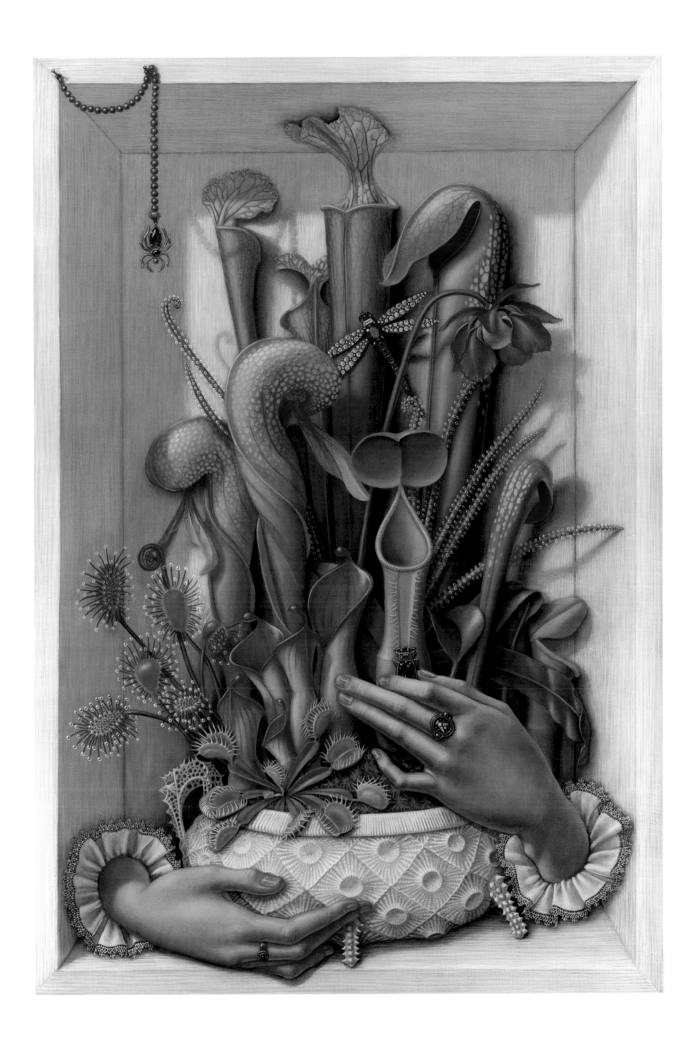

Nick Brandt

British, b. 1964
Line of Rangers Holding the Tusks of Elephants Killed at the Hands of Man, Amboseli, from *Across the Ravaged Land,* 2011
Archival pigment print
44 x 78 in.
Courtesy of the artist

As I write, there is a continent-wide apocalypse of all animal life now occurring across Africa. When you fly over such a vast continent with so much wilderness, it's hard to imagine that there's not enough room for both animal and man. But between an insatiable demand for animal parts and natural resources from other countries, and a sky-rocketing human population, the animals are being relentlessly squeezed out and hunted down.

—Nick Brandt

More than thirty thousand elephants are killed every year. To spotlight the slaughter of the planet's largest land animals, Nick Brandt staged *Line of Rangers Holding the Tusks of Elephants Killed at the Hands of Man* to echo the composition of an earlier work, *Elephants Walking Through Grass.* A year later, the artist learned that the herd's matriarch was killed for its ivory. One in five elephant herds are currently orphaned in this way, depriving youngsters the knowledge for survival.

Brandt has spent much of his career in Africa championing the conservation of its vanishing wildlife and habitat. In 2000, he began a trilogy of books that document a decade-long photographic journey honoring these "sentient creatures not so different from us."

The African elephant population has plummeted from about four million in the early twentieth century to 415,000 today. Less than 20 percent of elephant habitat is formally protected. To help meet this need, Brandt co-founded Big Life Foundation, which has hired hundreds of rangers to safeguard the Amboseli National Park ecosystem that connects Kenya and Tanzania.

According to a report from the United Nations Environment Programme, illegal wildlife trafficking in Africa alone is a multi-billion-dollar-a-year industry, ranking fourth on the global black market.[1] However, some encouraging news has emerged from China, the largest market for ivory, which has committed to end commerce in 2018.

Throughout history, the elephant's impact on human culture has been profound. As both a beast of burden and revered for its power to bring good luck, the elephant has been celebrated by many authors, from Rudyard Kipling to Doctor Seuss. The animal also figures prominently in the ritual art of indigenous African communities. A world without this creature, whose evolutionary roots parallel the great woolly mammoth, would be tragic not only for the planet's biodiversity but also for the only species with the power to ensure its survival.

NOTES

1 Reported by the World Economic Forum: Philip Muruthi, "The Economics of Africa's Wildlife," March 3, 2015, https://www.weforum.org/agenda/2015/03/the-economics-of-africas-wildlife/.

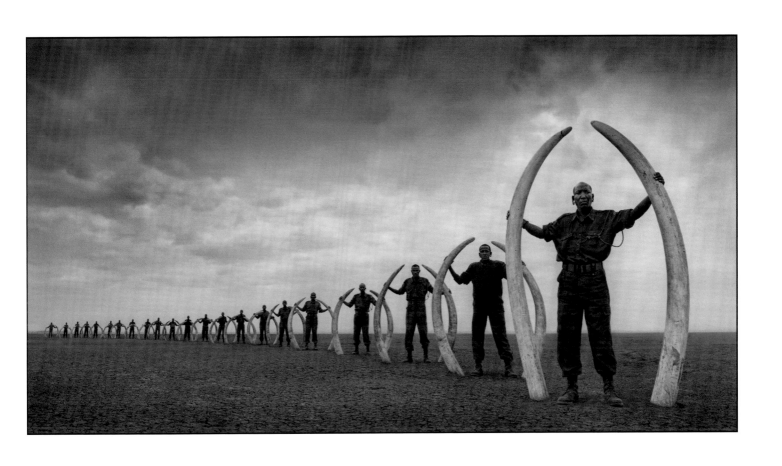

Michael J. Felber

American, b. England, 1946
Arctic Father, 2017
Colored pencil
22½ x 30 in.
© Michael Felber 2018, Courtesy
of the artist

In this intimate portrait of a polar bear, Michael Felber conveys the animal's grandeur and vulnerability. Based on photographs taken by the artist in Svalbard and Greenland, the drawing is a requiem to a species in peril.

By calmly inviting our gaze, *Arctic Father* dramatically contrasts with nineteenth-century interpretations of wildlife that catered to humanity's perception of particular animals as monsters. Edwin Landseer's popular *Man Proposes, God Disposes* (1864) was among the artworks that portrayed polar bears as vicious creatures, contributing to a warped vision of this animal's behavior.

Arctic Father calls attention to a challenging international conservation project that monitors remote populations of polar bears and their prospects for survival. On June 29, 2016, Felber observed this polar bear tagged as Number 14. After contacting the director of the Norwegian Polar Institute's monitoring project, he obtained data that suggested the drawing's title.

Tagged a year earlier, Number 14 is an eleven-year-old male in his prime. (Bears in Svalbard rarely live longer than twenty years.) At the time, he was accompanied by a female of approximately the same age. Felber emailed his photograph, with the coordinates of the animal's location, to the scientist, who learned that Number 14 was healthy and had migrated forty-five miles from the spot where he was captured, studied, and released.

Monitoring the more than twenty-six thousand polar bears roaming through Canada, the United States (Alaska), Russia, Greenland, and Norway (Svalbard) has assumed great importance in light of the Arctic's changing climate. Triggered by human activities, warming temperatures have significantly melted the floes on which polar bears breed, travel, and fish. The animals are also threatened by increasing fossil fuel exploration along with destructive ice-breaking and shipping activities in the Arctic Ocean.

In 2008, the Endangered Species Act listed polar bears as threatened. The same human pressures on polar bears have also negatively impacted indigenous peoples whose resilient cultures, developed over thousands of years in response to an extreme environment, are in jeopardy.

EDWIN HENRY LANDSEER, *Man Proposes God Disposes*, 1864, oil on canvas, Royal Holloway, University of London.

Preston Singletary

American Tlingit, b. 1963
Killer Whale, made at Museum of Glass, 2009
Blown glass and sand-carved glass
25 x 16 x 7 in.
Collection of Museum of Glass, Tacoma, Washington, Gift of the artist

The artistic perspective of indigenous people reflects a unique and vital visual language which has connections to the ancient codes and symbols of the land, and this interaction has informed and inspired my own work.

—Preston Singletary

Preston Singletary transforms the image of an orca, often called a killer whale, into an unusual sculpture that captures the charisma of the animal. By integrating the abstraction of Pacific Northwest Formline design into glass, the artist energizes both Native American art and the contemporary glass medium.

For centuries, the Tlingit and other indigenous peoples of the Northwest Coast have revered the orca. Specific clans identify with the whale's awesome powers through art and ritual. Only artists within this clan have the privilege of carving killer whale ceremonial masks and depicting the animal on totem poles and house screens. Singletary, a Tlingit who holds this honor, continues to assert the animal's fundamental role in native culture.

Tragically, the orcas in Puget Sound are now threatened with extinction. The southern resident orcas numbered only seventy-six individuals in October 2017. They are currently listed as endangered under the Endangered Species Act. This population, unlike transient orcas that feed on marine mammals, depends on fat-rich Chinook salmon for survival.

The Chinook, a keystone salmon species, supports more than 125 animal species, such as bears, eagles, and river otters. They are currently listed as threatened in the Columbia River and Puget Sound, where orcas feed in early spring and summer. (The spring-run Chinook are listed as endangered in the Upper Columbia River.) Other threats to the whales include ocean pollution and excessive noise from boats that interfere with echolocation, their ability to find food.

The interconnection between Chinook salmon and orcas underscores the importance of looking at the health of entire ecosystems. A proposal to establish a binational Salish Sea Marine Sanctuary and Coast Trail would strengthen not only the two species currently at risk but also the health of mountains and rivers of the entire watershed.

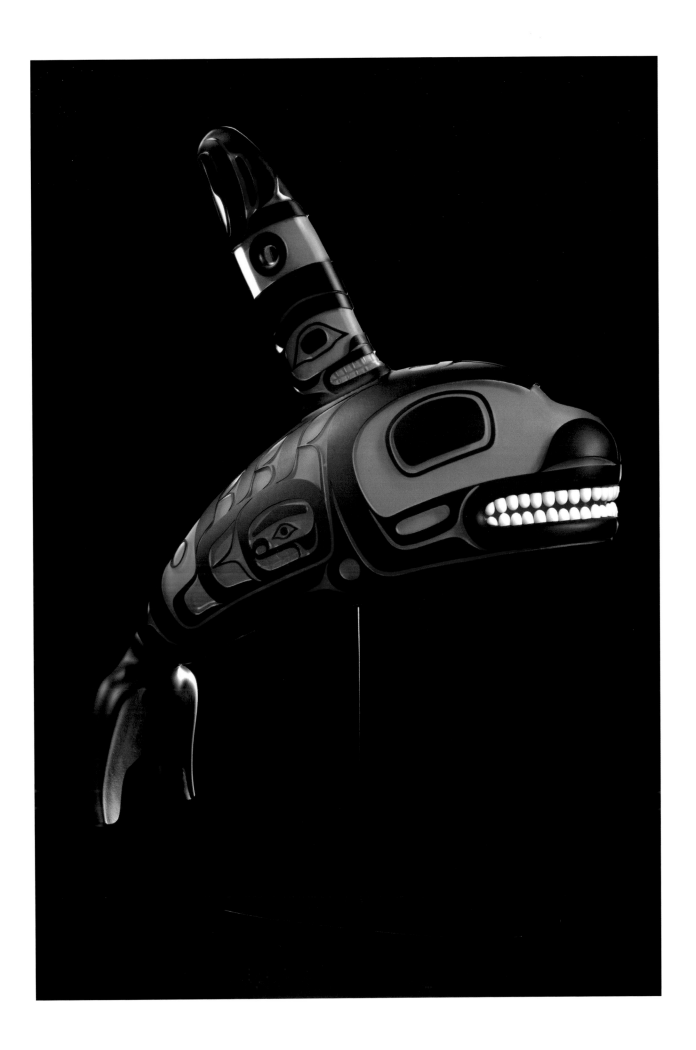

Julie Andreyev and Simon Lysander Overstall

Canadian, b. 1962 and 1969
Salmon People, 2010–2015
Still from recombinant multi-channel audio-video installation,
12:00 minutes
Courtesy of the artists

Sockeye salmon have adapted to survive an extraordinary migration from the Pacific Ocean, up the Fraser River, to their inland spawning grounds 269 miles away. Can the species now withstand the assault of water pollution and climate change that elevates temperatures beyond the salmon's cool aquatic environment? Julie Andreyev and Simon Overstall frame the challenges facing these fish through colliding imagery from the Adams River, among the most significant salmon breeding areas in North America, and the urban and industrial environments of Vancouver and Surrey, British Columbia.

Salmon are threatened by habitat loss, hydroelectric dams on migratory rivers, overharvesting of rare stocks, and competition with hatchery fish. Consequently, about 35 percent of the Fraser River sockeye salmon subpopulations are listed as endangered by the International Union for the Conservation of Nature.[1] In Washington State, five out of eight subpopulations of this species have been declared extinct, with one critically endangered and two near threatened.

Pacific Northwest salmon are keystone species, which means that an entire ecosystem, including humans, depend upon them for survival. Even the forests, fertilized by decaying salmon carcasses, are nourished by this fish. Sacred to indigenous peoples, salmon feature prominently in art and Northwest Coast cultural identity.

Salmon People was first exhibited in 2015 on Urbanscreen, an outdoor panoramic installation wall on Surrey's Chuck Baily Recreation Center. A three-channel video of changing combinations of imagery became an immersive environment, enhanced by natural and synthesized soundscapes. The video was funded by Emily Carr University of Art + Design, where Andreyev is an associate professor.

Production Team: Julie Andreyev, direction and video editing; Simon Lysander Overstall, installation software and sound design; Paolo Pennuti and Elisa Ferrari, Adams River cinematography; Jonathan Nunes, Fraser River cinematography.

NOTES

1 Subpopulations are defined by the IUCN as geographically or otherwise distinct groups in the global population where there is little demographic of genetic exchange.

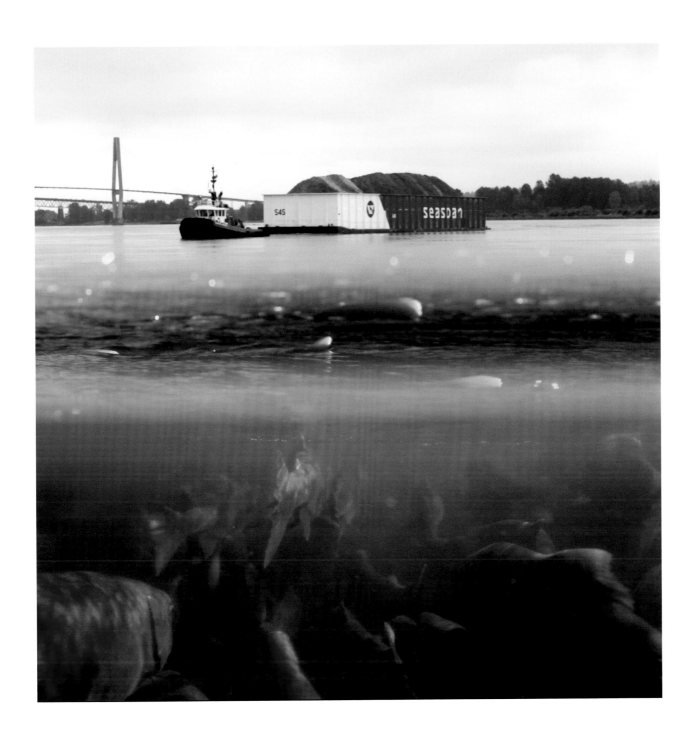

In 1982, Joseph Beuys planted the first tree of *7000 Oaks* in Kassel, Germany. This eco-artwork took five years to complete.

AT THE CROSSROADS
Destruction or Preservation of Biodiversity

According to the United Nation's Protected Planet Report, only 15 percent of Earth's land surface and 4 percent of the oceans are protected. . . . I am convinced that only by setting aside half the planet in reserve, or more, can we save the living part of the environment and achieve the stabilization required for our own survival.

—EDWARD O. WILSON, *Half Earth*, 2016

Artists respond to scientific data about species extinction and environmental degradation by interpreting the human activities responsible for biodiversity's decline. Their evocative, haunting works broaden our understanding of these problems and inspire the conservation of wildlife and ecosystems. Human pressures on biodiversity have been assigned the acronym HIPPO by biologist E.O. Wilson:

Habitat Loss
Invasive Species
Population Growth
Pollution
Overhunting / Overfishing

All of these interconnected stresses to the natural world are exacerbated by climate change.

Although these problems seem daunting, the commitment of engaged citizens working to protect and revitalize biodiversity offers encouragement and guidance. Artists are in the forefront of this planetary effort, creatively mitigating environmental distress through their work.

In the late 1960s, artists began envisioning new, creative strategies to enhance life and restore the essential bond between people and the natural world. They designed works that actually revived depleted habitats. This approach, called ecological art (or eco-art), has catalyzed ongoing remediation projects, some of which are documented here.

During these multi-year restoration efforts, artists collaborate with natural scientists, museums, policy makers, and community volunteers, among others. Although relatively limited in scale or conceptual in form, eco-artworks serve as models for enhancing land- and water-based biodiversity in urban and outlying areas.

HABITAT LOSS

We abuse land because we regard it as a commodity belonging to us.
When we see land as a community to which we belong, we may begin
to use it with love and respect.

—ALDO LEOPOLD, *A Sand County Almanac*, 1949

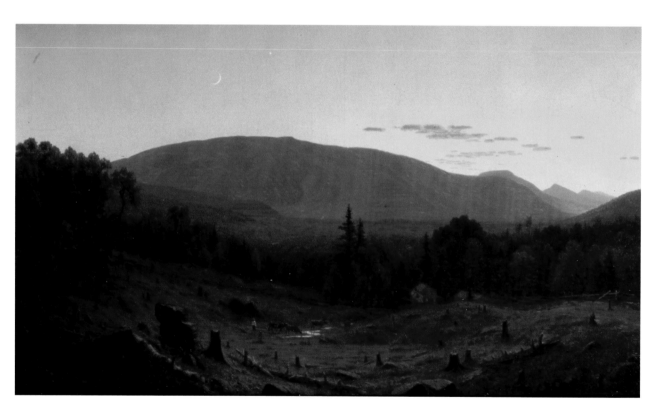

STANFORD ROBINSON GIFFORD, *Twilight on
Hunter Mountain*, 1866, oil on canvas, Terra Museum
of American Art, Chicago. This painting, informed
by photographs of fallen soldiers on Civil War
battlefields, was one of the first landscapes with
deforestation as a central theme.

Humans have transformed almost half of Earth's ice-free land surface, which is why habitat loss poses the greatest danger to biodiversity. Eighty-five percent of all species on the International Union for the Conservation of Nature's Red List are at risk because of the destruction, fragmentation, or degradation of their environment. Artists both call attention to this problem and conceive eco-artworks that help species recover.

Endangered Species highlights only a few of Earth's vulnerable ecosystems, including forests of the Pacific Northwest.[1] Of particular importance are tropical rainforests and coral reefs, which house the greatest number of unique species. Both are classified as biodiversity hotspots because of the extreme threats posed by human activities.

NOTES

1 According to World Resources Institute, approximately 15 percent of global forest cover remains intact, 30 percent has been cleared, 20 percent has been degraded, and 35 percent fragmented. See "Forest Fact Sheet," http://www.wri.org/sites/default /files/uploads/7-forest_fact_sheet.pdf.

POSITIVE STEPS

- Rewilding Europe, a program of partnering organizations, has committed to setting aside four thousand square miles to create ten wilderness areas where animals such as bison, wild horses, chamois, and wolves will be reintroduced.

- The Green Belt Movement in Kenya has planted over fifty-one million trees to restore watersheds. It generates income for local communities by creating profitable and sustainable uses of the forest. Similar reforestation projects, called Great Green Walls, are happening in China, Indonesia, and across Africa's Sahara desert.

- Conservation International is working with indigenous peoples and local communities to help steward their lands through innovative financial incentives. This is significant since communities in rural areas manage almost 25 percent of all Earth's land and water, representing 80 percent of the planet's biodiversity.

- The United Nations Convention on Biological Diversity advocates the preservation of traditional knowledge that embraces the sustainable use of biological diversity. Collaborations with local and indigenous communities are essential in this effort.

- The Yellowstone to Yukon Conservation Initiative connects fragmented ecosystems for wildlife to move freely along an expanded habitat corridor.

- Ten million acres have been secured for a new national park system in Patagonia, Chile, an area under siege from mining, logging, and agriculture. The park measures three times the size of Yosemite and Yellowstone National Parks combined.

Joel Sartore

American, b. 1962
Captive Northern Spotted Owl,
Merlin, Oregon, 2007
Archival inkjet print
30 x 45 in.
© Joel Sartore, Courtesy of the
artist

Many photographers have documented the devastation of clear-cut forests, but Joel Sartore also poignantly portrays the victims of this habitat loss. He places a spotted owl, loaned by Wildlife Images Rehabilitation and Education Center, in a logged-out section of land to spotlight damaging timber industry practices. Against this background, a conservation success story continues to unfold.

In 1990, the US Fish and Wildlife Service placed the spotted owl on the Endangered Species Act list as threatened. This sparked a federal court order and the adoption of the Clinton administration's Northwest Forest Plan. It established old growth reserves and conservation areas in Washington, Oregon, and Northern California to protect approximately twenty million acres of federal land from logging. The plan also provided job retraining for loggers and economic development for timber-dependent communities.

The spotted owl symbolizes how the Endangered Species Act can protect wildlife from extinction while preserving critical ecosystems on the verge of collapse. Unfortunately, the bird's numbers continue to decline due to the migration of barred owls, an invasive species from eastern North America. They outcompete the spotted owl for limited nesting sites. Ultimately, virgin forests have been saved and ecotourism has helped in the recovery of many timber towns once hostile to conservation efforts.

Captive Northern Spotted Owl reflects Sartore's worldwide quest to document every endangered species held in human care. Titled the *Photo Ark,* this twenty-five-year project invites comparison with John James Audubon's *Birds of America* (1826-1838). The *Photo Ark* was the subject of RARE, a three-part television series that aired in 2017 on the Public Broadcasting Service.

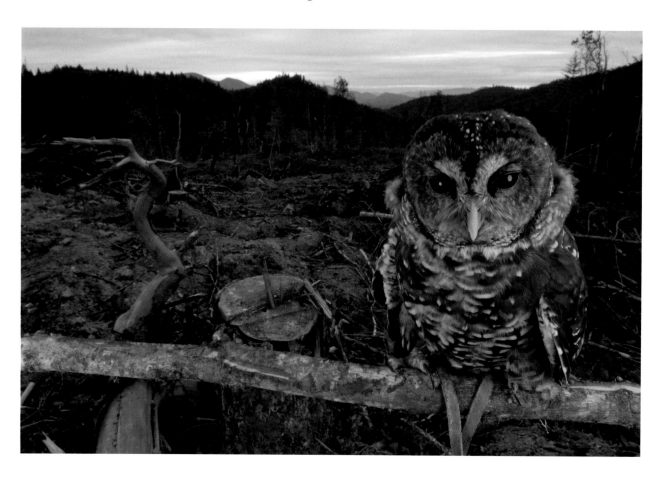

Darius Kinsey and Tabitha Kinsey

American, 1869–1945
and 1875–1963
*Man lying in the completed
undercut of a twelve-foot cedar*,
1906
Black-and-white photograph
made from an 11 x 14 in. silver
gelatin dry plate negative
Whatcom Museum, 1978.84.185

Beginning in the mid-nineteenth century, logging was the economic lifeblood of the Pacific Northwest for more than a hundred years. Darius Kinsey, who lived in Washington during logging's heyday, documented the industry through photography.

Kinsey worked on commission for logging companies and satisfied the demand for portraits of individual loggers at work. His wife, Tabitha, developed and printed the negatives. With forty-five hundred original negatives in its collection, the Whatcom Museum holds the largest repository of the couple's work.

Monumental old growth trees, as seen in the Kinseys' photographs taken with a large-format camera, evoke awe. Most of these giants, which once thrived for hundreds of years before the arrival of settlers, now live only as photographic documents of loss.

The surviving trees are home to the threatened spotted owl. Since the 1990s, the Endangered Species Act has protected these birds by preserving remnants of their old growth habitat on national forest and state lands. Currently, approximately 15 percent of Western Washington's forest area is considered in old growth condition.

The Kinseys' photographs bear witness to an era of rampant ecosystem destruction. They underscore the necessity of promoting sustainable logging practices to counter the clear-cutting assault on forests that continues today.

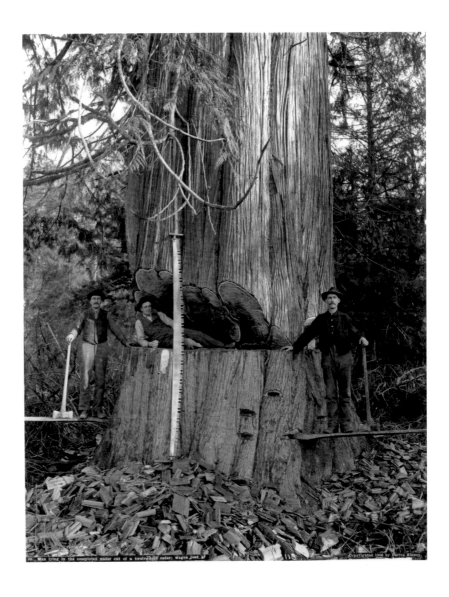

Lawrence Paul Yuxweluptun

Canadian First Nations (Coast Salish-Okanagan), b. 1957
Clear Cut to the Last Tree, 1993
Screen print on paper
28 x 18 in.
Collection of the Vancouver Art Gallery, Vancouver Art Gallery Acquisition Fund, VAG 94.14.1

It's part of being a history painter. You don't always like the subject matter, but someone has to do it. That's the difficult thing of gazing at your own culture: you have to accept what's in front of you.

—Lawrence Paul Yuxweluptun

The intimate scale of *Clear Cut to the Last Tree* entices viewers to peer into a haunting drama of great beauty and desperation. Lawrence Paul Yuxweluptun conjures an apocalyptic scenario by reinterpreting the dream world of European Surrealism and traditional Northwest Formline design, which firmly establishes the landscape as native ground.

This startling fusion of styles from two distinct cultures symbolically references diverging attitudes toward Pacific Northwest old growth forests. Once stretching unbroken from mountains to sea, trees provided indigenous peoples with everything needed for survival, including materials for ritual art. Alive with meaning and sacred spaces, the forest sustains Northwest culture in the same way that the buffalo nurtured life on the Great Plains.

By contrast, the artist reminds viewers that the settlers who claimed indigenous lands during the nineteenth century considered the forest a commodity. Clear cutting continues to devastate mountains, which literally slide away without their anchor of tree roots. The disembodied mountain in *Clear Cut to the Last Tree* suggests this process of disintegration.

The artist, born into a family of notable activists, sees himself as a history painter in the tradition of European old masters. Instead of mining stories from classical literature, he introduces the critical issues that currently face First Nations people. As was the practice of earlier artists, Yuxwelupton made a preliminary sketch for this composition. In 2013, he painted with acrylics a heroically scaled version of *Clear Cut to the Last Tree*, which belongs to the Audain Art Museum in Whistler, British Columbia.

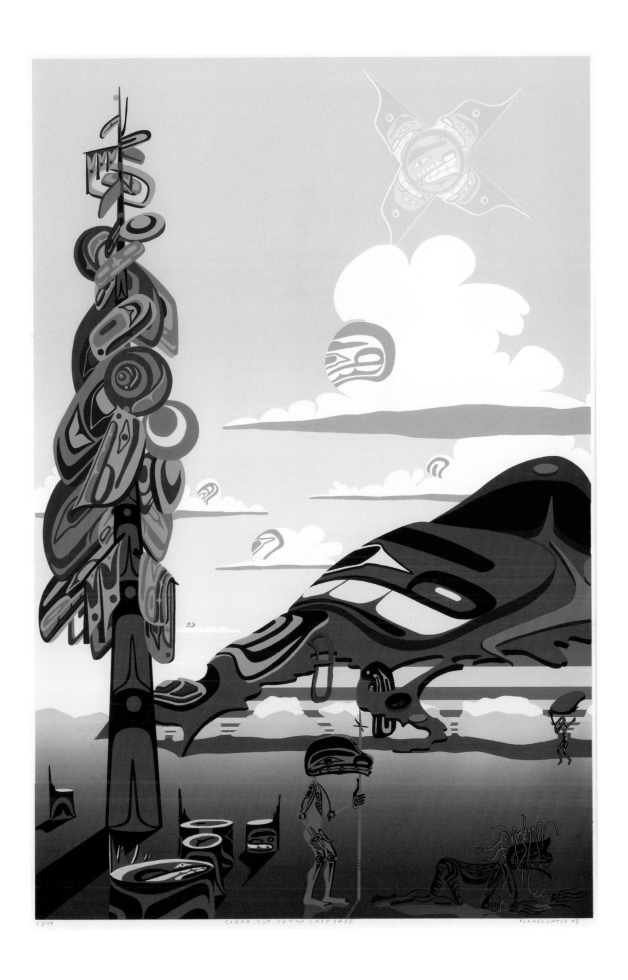

Jason Walker

American, b. 1973
A Hand in Two Worlds, from the
series *Human Made Wild*, 2008
Porcelain, underglaze, luster, and
concrete
13½ x 19 x 7 in.
Collection of Deb McCunn

In *A Hand in Two Worlds*, Jason Walker innovatively blends drawing and ceramic sculpture to convey the effects of habitat loss on wildlife. A lone grizzly bear appears trapped on an urban freeway. In the adjacent scene, the fate of humankind looks just as terrifying.

A gentler scenario unfolds in expansive landscapes on the flip side of the sculpture, where Walker's self-portrait appears. For the artist, the bear symbolizes wilderness and the hand cradling this creature perhaps offers protection.

A Hand in Two Worlds resonates more poignantly since 2017. Trophy hunting for grizzlies within the greater Yellowstone ecosystem is now permitted after the loss of Endangered Species Act safeguards. In addition, plans to reintroduce grizzles to Washington State's North Cascades National Park have met both resistance and support.

Walker emphasizes the tension between humans and wildlife in his three-dimensional frame, a synthesis of animal and machine that unifies the four compositions. With technology becoming the lens through which people now define themselves, the artist compels us to reconsider our relationship with the natural world.

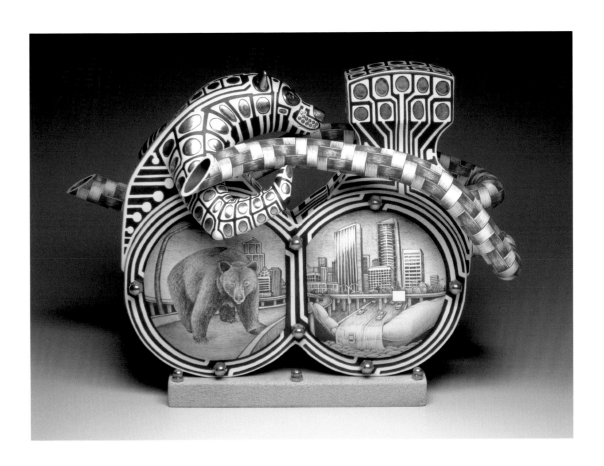

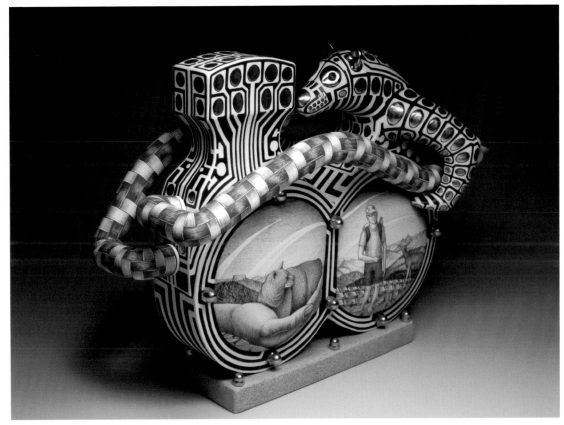

Adam Kuby

American, b. 1961
Cliff Dwelling (proposal for a
sculpture that provides nesting
habitat for peregrine falcons on a
skyscraper), 1993
Lithograph, pastel, and
watercolor on paper
24 x 40 in.
Courtesy of the artist

When Adam Kuby first proposed *Cliff Dwelling*, peregrine falcons were recovering from near extinction in North America. Their return began in the 1970s, thanks to the protection of the Endangered Species Act and the ban on the toxic pesticide DDT.

More than six thousand peregrine falcons have been reintroduced into the wild by Cornell University's Peregrine Fund, in conjunction with state and federal fish and wildlife agencies.[1] The species was removed from Endangered Species Act listing in 1999.

Cliff Dwelling reflects the fact that peregrine falcons favor steep rock faces and, it was discovered, skyscrapers. Cities are surprisingly a haven for about 20 percent of the world's avian biodiversity.[2] Kuby's panoramic window, designed for humans to observe falcons, takes advantage of this little-known aspect of urban life.

Kuby's eco-art practice embraces landscape architecture and restoration, urban forestry, and zoo habitat design. In 2012, he created a public artwork in Seattle titled *hydro-geo-bio*. It includes a rain garden and twenty-nine cavity-nesting bird houses in a fourteen-foot-tall stormwater holding tank. Enhancing biodiversity, this project underlines the connection between earth, water, and life.

NOTES

1 Other partnerships include the Midwestern Peregrine Falcon Restoration Project and the Santa Cruz Predatory Bird Research Group.

2 Richard Coniff, "Urban Nature: How to Foster Biodiversity in World's Cities," *Yale Environment 360*, January 6, 2014, http://e360.yale.edu/features/urban_nature_how_to_foster_biodiversity_in_worlds_cities.

TROPICAL RAINFORESTS

At first I thought I was fighting to save rubber trees, then I thought
I was fighting to save the Amazon rainforest. Now I realize I am
fighting for humanity.

—**CHICO MENDES,** trade union leader and environmental activist

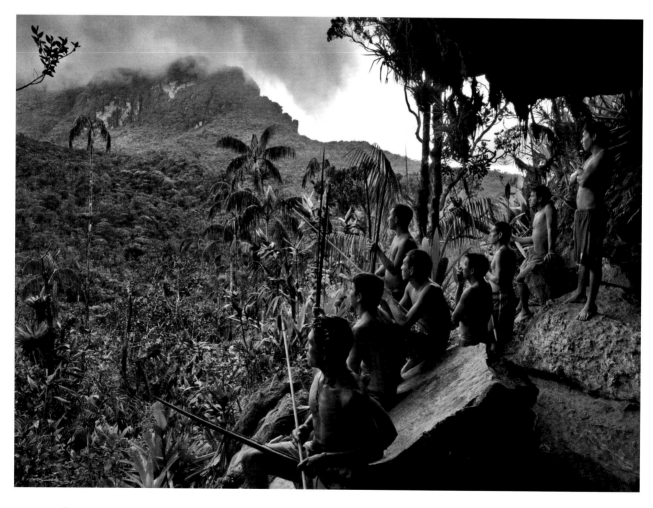

SEBASTIÃO SALGADO, *Yanomami warriors look
out to the mountain vegetation on the flanks of Pico da
Neblina (Mist Peak), rising almost 10,000 feet above
sea level,* April 2014, gelatin silver print, © Sebastião
Salgado/Contact Press Images.

Why Are They Important?

Tropical rainforests, the most complex ecosystems on Earth, are home to over 50 percent of the world's species. Amazingly, these "lungs of the world" generate about 40 percent of the planet's oxygen, but cover only 6 percent of its surface.[1] The cheapest and most effective way to mitigate the planet's changing climate is to preserve as much of these forests as possible. By contrast, burning down the trees for agriculture releases massive amounts of carbon, making it one of the largest single contributors to climate change.

Biologists consider the rainforest a biodiversity hotspot because the lives of countless plants and animals, and close to four hundred different groups of indigenous peoples, are endangered by development. Within this context, Alexis Rockman's drawing of animals precariously perched on a leafless limb becomes emblematic of this crisis.

Rainforests Face an Uncertain Future

Vast expanses of rainforests have been cleared by slash-and-burn agricultural practices for beef production and the industrial farming of soy, sugar, and palm oil. High consumer demand in industrialized countries for these commodities fuels this deforestation.

Daniel Beltra's photographs dramatically capture these destructive and unsustainable activities in this ecosystem with acidic and low-nutrient soils that offer little fertility. Vast amounts of chemical fertilizers must be continually applied or a vicious cycle of slash-and-burn maintained until the forest is gone.

Humans have been living in the rainforest for more than eleven thousand years. Their culture, along with the knowledge of the forest's countless medicinal plants, is in jeopardy.

NOTES

1 "Rain Forests," National Geographic, August 18, 2017, https://www.nationalgeographic.com/environment/habitats/rain-forests/.

POSITIVE STEPS

- The Brazilian government partnered with the World Wildlife Fund and other organizations to protect 150 million acres (15 percent) of the country's Amazon rainforest. This represents the world's largest network of protected areas.

- The Peruvian government recently announced plans to establish Yarugas National Park to preserve over two million acres of rain forest. The area includes 3,000 species of plants, 500 species of birds and 160 species of mammals, including giant otters, woolly monkeys, Amazonian river dolphins, and manatees.

- The New York Declaration on Forests, under the auspices of the United Nations Climate Summit, created a voluntary plan for cutting forest loss in half by 2020 and ending it completely by 2030. The plan encourages corporations to commit to zero deforestation by disallowing crops grown in illegally cleared areas from entering their supply chains.

- The Global Forest Watch website provides essential tools and mapping information that quickly detects illegal gold mining and logging in protected areas. It includes an interactive map of every forest in the world along with land-use data.

- The United Nations REDD program (Reducing Emissions from Deforestation and Forest Degradation in Developing Countries) offers monetary and technical assistance to governments, landowners, and villagers who protect their forests. Administered by the World Bank, funding has been provided by industrialized countries for both strategic plans and implementation.

Daniel Beltrá

American and Spanish, b. 1964

Man-Made Fires to Clear the Land for Cattle or Crops: Amazon Rainforest, 2008
Archival digital print
40 x 60 in.
Courtesy of the artist

Large areas of rainforest have been turned to fast-growing eucalyptus forests in the past decade to provide the Japanese and European paper-making industries, 2017
Archival digital print
40 x 60 in.
Courtesy of the artist

Daniel Beltrá has been documenting the fragmentation and destruction of Amazon rainforests since 2001. This dramatic photograph encapsulates a chain of events that often begins with the construction of an illegal road. Loggers soon arrive to harvest mahogany and other hardwoods, and ranchers burn the remaining trees to clear land for grazing cows.

Cattle ranching accounts for 70 percent of Amazon deforestation. Much of the agricultural activities are dominated by large corporations and revolve around soybeans grown for animal feed. Beef exported for human consumption and rainforest destruction go hand in hand.

Beltrá is a conservation photographer with university degrees in forestry engineering and biology. Using aerial photography to capture the vast devastation of ecosystems, he interprets how Earth's resources are quickly depleted. His new book, *Forests*, features photographs of disappearing rainforests in Brazil, the Democratic Republic of the Congo, and Borneo, Indonesia. It includes a poignant plea for action by primate biologist Jane Goodall.

Commissioned by Greenpeace, Daniel Beltrá visited the northern Brazilian state of Amapa, the last frontier of the Amazon rainforest. In this photograph a huge swath of eucalyptus trees destined for the Japanese paper-making industry has displaced the biodiversity of the rainforest.

Virgin forest still dominates 90 percent of Amapa, which also includes the largest tropical forest park in the world, Tumucumaque Mountains National Park. The region is now threatened by off-shore oil drilling, the industrial agriculture of soy bean, and increased gold mining, which has polluted city water supplies with mercury.[1]

NOTES

1 John Vidal, "Brazil's Forgotten State: Oil and Agrabusiness Threaten Amapá Forests—In Pictures," *Guardian*, February 16, 2017, https://www.theguardian.com/environment/gallery/2017/feb/16/brazils-forgotten-state-oil-agribusiness-threaten-amapa-forests-in-pictures.

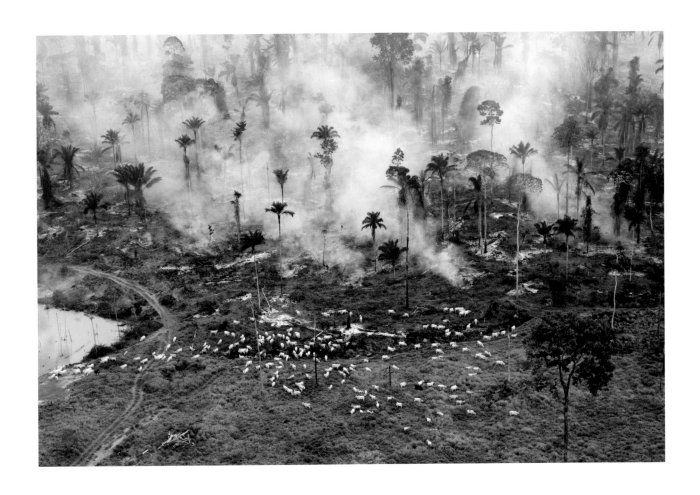

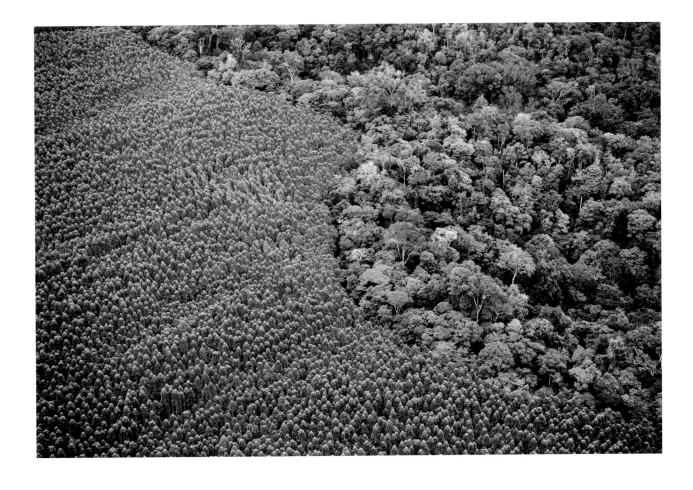

Alexis Rockman

American, b. 1962
Fragments, 2010
Watercolor and ink on paper
24 x 18 in.
Collection of Lemur
Conservation Foundation,
Myakka City, Florida

In *Fragments*, Alexis Rockman paints the red-ruffed lemur, a primate that lives only in the rainforests of Madagascar. Perched precariously on a fire-scarred limb, the animal—with its green eyes—confronts the viewer. The painting elicits sympathy for the world's most endangered mammal by interpreting what statistics cannot express. According to the International Union for the Conservation of Nature, 90 percent of the one hundred lemur species, endemic to Madagascar, face extinction within the next twenty-five years.

In Madagascar, only 16 percent of the forest landscape remains intact, due to logging and slash-and-burn agriculture for rice propagation. Rockman incorporates tiny trucks and earth-moving equipment into his composition to indicate the human activities responsible for deforestation. He also remembers the once-lush rainforests of Africa, India, and Southeast Asia in the form of a map-like silhouette of these countries, a ghostly, green reminder of lost ecosystems.

Rockman traveled to Madagascar in 2009 with the founder of the Lemur Conservation Foundation. He had become interested in tropical ecology through his early relationship with New York City's American Museum of Natural History. The artist was invited by the museum to explore the Brazilian rainforest in conjunction with biologist Thomas Lovejoy's study of forest fragmentation. A large oil painting, also titled *Fragments*, was reproduced on the cover of the museum's *Natural History* magazine in 1998. One of Rockman's field study sketchbooks, the foundation of his larger works, is also featured in *Endangered Species*.

Catherine Chalmers

American, b. 1957
Still from *We Rule,* from
Leafcutters series, 2013
Video with sound, 4:12 minutes
Courtesy of the artist

They [leafcutter ants] do not clear cut rainforests quite like we do, but they can strip a tree in a single night, and repeat this night after night. At a time in history when humans are causing deforestation at an alarming rate, this insect provides rich and relevant opportunities for illuminating man's impact on the environment.

—Catherine Chalmers

For more than eight years, beginning in 2007, Catherine Chalmers collaborated with wild leafcutter ants at biological field stations in Panama and Costa Rica. By studying and working in tandem with ant behavior, she reveals parallels with our own species. In *We Rule*, Chalmers links the insatiable defoliating capacity of ants with the human destruction of forests.

The artist's photographs and films, shot on location, also accentuate the beauty and complexity of the ant colony's powerful organizational structure. By introducing ants to Bougainvillea flowers, delicate seeds, and letters of the alphabet cut from citrus leaves that spell "we rule," she frames compositions defined by colony movement.

During her expeditions, Chalmers noticed that different ant colonies exhibited different behaviors, or personalities. Some accepted her offerings and others ignored them. Her *Leafcutters* series evolved as her understanding of these insects grew. The artist recognized that "their preferences, what they decide to take when I'm there, establish not only the aesthetics of the video, but more significantly, influence the formation of the narrative." This give and take between a human and leafcutter ants becomes a metaphor for the interdependency of species.

CORAL REEFS

Ice ages have come and gone. Coral reefs have persisted.

—**SYLVIA EARLE,** marine biologist and first female chief scientist of the
US National Oceanic and Atmospheric Administration

ANNE VALLAYER-COSTER, *Still Life with Tuft of
Marine Plants, Shells and Corals,* 1769, oil on canvas,
Louvre, Paris.

Why Are They Important?

Coral reefs, the most diverse of all marine ecosystems, are often called the rainforests of the sea. Covering less than 2 percent of the ocean floor along the equator, they feed and shelter 25 percent of all marine life. Half a billion people depend on these reefs for food.[1]

Reefs are colonies of tiny marine animals joined together to create hard skeletons of calcium carbonate. Corals survive through a symbiotic relationship with microscopic algae, which absorb the sun's energy to produce the reef's food. Through this process, they become the largest biological structures on Earth.

The Bleaching and Dying of Coral Reefs

The fragility of coral reefs make them vulnerable to global pollution and climate change. When stressed by rising ocean temperatures, they expel the algae living in their bodies. The loss of this food source triggers the bleaching process and the white skeletal remains mark the reef's death.

Australia's Great Barrier Reef, at seven thousand years, is the world's largest and oldest coral reef. It succumbed to mass bleaching events in 2016 and 2017. Courtney Mattison's large sculptural installation spotlights this devastating phenomenon.

As oceans absorb acidic carbon dioxide emissions from the atmosphere, corals have difficulty constructing their protective skeletons. In an effort to replenish reef ecosystems, Jason deCaires Taylor creates underwater sculpture parks that regenerate coral and lure tourist divers away from more fragile reefs.

NOTES

1 Emily Frost, "Corals and Coral Reefs," *Ocean Portal*, Smithsonian National Museum of Natural History, October 16, 2017, http://ocean.si.edu/corals-and-coral-reefs.

2 "Explore the World's Marine Protected Areas," *Protected Planet*, World Database on Protected Areas, last modified March 2018, https://www.protectedplanet.net/marine.

POSITIVE STEPS

- Marine Protected Areas have been designated around the world. As of 2017, almost 16 percent of marine areas within national jurisdiction are protected, including most recently the expansion of the Papahanaumokuakea Marine National Monument in Hawaii, and a marine preserve around the Pitcairn Islands in the Pacific Ocean.[2]

- A new philanthropic initiative, 50 Reefs, is working with marine biologists to identify fifty of the world's most resilient reefs. In addition to conserving the reefs, they will establish coral seed banks to restore distressed reefs in the future.

- The Florida Aquarium and the Florida Key National Marine Sanctuary have begun to rescue and grow coral in underwater nurseries dedicated to revitalizing damaged reefs.

Courtney Mattison

American, b. 1985
Afterglow (Our Changing Seas VI),
2018
Site-specific installation for
Whatcom Museum
Hand-sculpted and glazed
stoneware and porcelain
7½ x 8½ x 1½ ft.
Courtesy of artist

I want viewers to feel the way I do when I slowly hover over a coral reef while scuba diving, discovering tiny details in every crevice and feeling as though they're among precious—and very delicate—life forms. I want them to understand how tragic it would be to lose these ecosystems and to feel empowered to help.

—Courtney Mattison

Courtney Mattison's *Afterglow* highlights a unique and imperiled ecosystem that harbors the planet's richest marine biodiversity. The artist visualizes the devastating effects of coral bleaching by contrasting the reef's vividly colored, intricate forms with an advancing wave of whitened skeletons. In the past thirty years, 50 percent of coral reefs have disappeared due to rising ocean temperatures caused by climate change. [1]

In *Afterglow*, Mattison paints the edges of her sculpture with fluorescent colors to interpret a phenomenon displayed by certain coral when the ocean reaches high temperatures. On the brink of bleaching, they produce fluorescent proteins that function like sunscreen protection. This process signals a last-ditch effort to survive. According to the artist, "It's seen as a precursor to sickness and death that is eerily vibrant, like a final burst of energy before succumbing to a disease."

Mattison does not sculpt accurate dioramas. Instead, she reveals her interpretive "fingerprints" through the modeling of clay and invention of "hybrid species." The American Association for the Advancement of Science and Nova Southeastern University's College of Oceanography recently commissioned Mattison to create permanent installations for their buildings. With degrees in marine ecology, environmental studies, and ceramic sculpture, Mattison expands the tradition of coral reef imagery first popularized by the artist-biologist Ernst Haeckel.

NOTES

1 Elena Becatoros, "More Than 90 Percent of World's Coral Reefs Will Die by 2050," *Independent*, March 13, 2017, http://www.independent.co.uk/environment/environment-90-percent-coral-reefs-die-2050-climate-change-bleaching-pollution-a7626911.html.

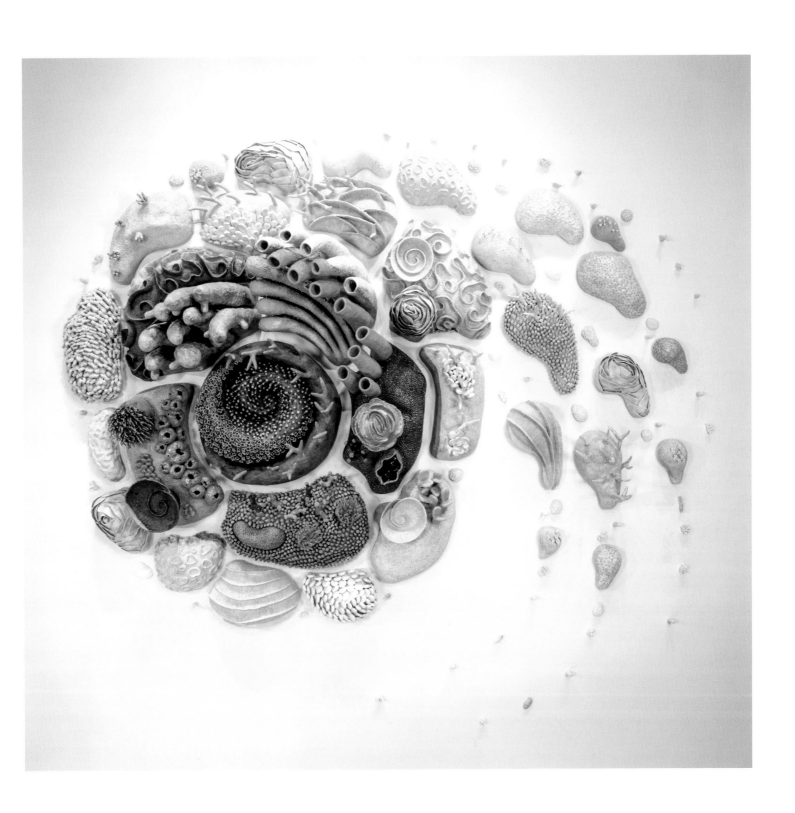

Xavier Cortada

American, b. 1964
Reclamation Project / Reclaiming
Mangroves: Reforestation of 2,500
mangrove seedlings on Virginia
Key, FL, April 2008
Photograph
Courtesy of the artist

In using arts and culture to build community, we often forget that the greatest resource isn't necessarily the program we design, or the object we create, or the idea we generate. It is the people themselves.

—Xavier Cortada

The *Reclamation Project* is Xavier Cortada's response to the loss of Florida's mangrove trees. His eco-artwork revitalizes mangrove forests, one of Earth's most biodiverse ecosystems. Working with botanists, Cortada began collaborating with Miami merchants, who raised twenty-five hundred red mangrove seedlings and displayed them in storefront windows for a year. Community volunteers then planted the seedlings along the barrier island of Key Biscayne. Similar collaborations in other locations followed, including in the nearby Virginia Key featured in this photograph and accompanying video by Bill Bilowit.

Unique to salt water swamps between land and sea, mangrove trees shelter a wide range of animals. Seventy-five percent of all tropical fish are born among the extraordinary roots of mangrove forests. Mangroves also protect humans from the flooding and coastal erosion caused by hurricanes. By filtering toxins, mangroves are essential for the health of threatened coral reef ecosystems.

Mangrove forests are found only along the world's tropical coastlines. Drained for development, stressed by pollution, and cut down for fuel and lumber, they are among the most threatened habitats on Earth. The last decade alone saw destruction of 35 percent of the world's mangroves.[1]

Reforestation efforts such as *The Reclamation Project* help protect these environments. The Miami Science Museum (now Frost Science Museum) adopted and expanded the project, which now covers twenty-five acres of coastal habitat restored by seventy-five hundred citizen conservationists.

NOTES

1 Ivan Valiela et al., "Mangrove Forests: One of the World's Threatened Major Tropical Environments," *BioScience* 51, no. 10, (October 1, 2001), 807–815, https://academic.oup.com/bioscience/article/51/10/807/245210.

Jason deCaires Taylor

British, b. 1974
Photograph of *Vicissitudes,
Grenada, West Indies* featured in
*Jason deCaires Taylor and Museo
Subacuático de Arte (MUSA)*, 2011
Video with sound, 6:36 minutes
Courtesy of the artist

Art can uniquely give instruction on how we may thoughtfully
approach solutions necessary to repair the damage that human
negligence seems to wreak on our natural environment.

—Jason deCaires Taylor

This video documents Jason deCaires Taylor's aquatic museum in the
Caribbean Sea off the coasts of Mexico's Cancún, Isla Mujeres, and Punta
Nizu. Five hundred sculptures were cast from live models, sculpted, and
installed on the ocean floor to form an artificial reef in 2009.

With 90 percent of Caribbean coral reefs destroyed, Taylor creates
new habitats for the multitude of species that depend on these creatures
for survival. His well-publicized ecological art installations, encrusted with
new life, attract scuba-diving tourists away from remaining fragile sites
that suffer from overuse.

Taylor's photograph and video also highlight the artist's first under-
water sculpture park, installed in 2006 off the island country of Grenada.
Titled *Vicissitudes*, its seventy-five sculptures form part of an established
Marine Protected Area. Included in this ensemble are a circle of twenty-
six figures that celebrate the ethnic diversity of Grenada's children.

Taylor has completed four artificial reefs in both the Caribbean Sea and
other waters of the Atlantic Ocean using specialized materials that encour-
age coral growth. The success of his eco-artworks depends on a collaboration
with marine biologists, diving enthusiasts, and government leaders.

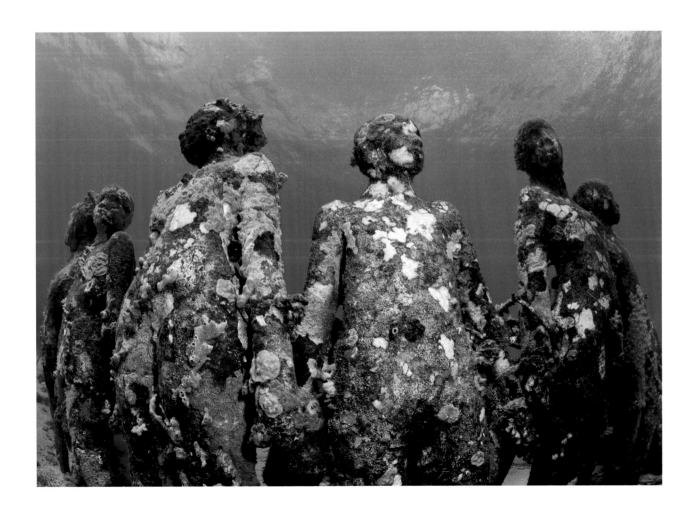

INVASIVE SPECIES

A lawn is nature under totalitarian rule.

—**MICHAEL POLLAN**, "Gardening Means War," *New York Times Magazine*, June 19, 1988

ISABELLA KIRKLAND, *Ascendant*, 2000, oil paint
and alkyd on canvas over panel. The artist portrays
seventy-four non-native species that have been
introduced in some part of the United States or its
trust territories.

Invasive species are non-native plants, animals, or micro-organisms whose introduction causes harm to the environment, human health, or the economy. These aliens damage habitats by out-competing native species for space, food, water, and light.

In the United States, invasive species threaten or endanger 42 percent of native plants. Hundreds of extinctions have already occurred. Most recently, tens of millions of ash trees have died due to an Asian beetle. The insect was introduced in 2003 via infested wood crating or pallets transported from China. In 2017, the International Union for the Conservation of Nature listed the American ash tree as critically endangered.

In Washington State, just a few invasive species—rush skeleton weed, Scotch broom, apple maggot, and zebra and quagga mussels—cost the state close to one billion dollars in resource damage and over five thousand lost jobs. The zebra mussel, native to Russia, was introduced to North America in the 1980s through ship ballast water. Now living in two-thirds of all US waterways, it contributes to the decline of native aquatic life.

Invasive species are often unintentionally spread by human activities: Uninformed gardeners plant them in backyards. Pet owners buy and set loose exotic animals. They arrive with certain products purchased by travelers, in ships whose ballast water carries aquatic organisms, and through wood products transported regionally and around the world.

Only a few artists have tackled the issue of invasive species. Penelope Gottlieb's mixed-media artworks, where alien plants entangle animals within a destructive web, evolved from her series on plant extinctions. Mark Dion, by contrast, graphically depicts domesticated animals introduced by colonial explorers, and the native North and South American species squeezed out by their arrival.

POSITIVE STEPS

- The National Agriculture Library of the US Department of Agriculture maintains a website listing more than 140 agencies and organizations across the country fighting invasive species. Many regions, states, cities, and local communities guard against invasive species by disseminating information about the habits and control of plants and animals that colonize native habitats.

- The National Association of Invasive Plant Councils provides resources such as definitions, identification guides, management suggestions, and current research. State and regional chapters also encourage early detection and citizen-science programs.

- Many cities, including Bellingham, Washington, have created governmental positions to control invasive species. These jobs focus on education, early detection monitoring, and rapid response efforts.

- Inspection of boats entering lakes and rivers has proved successful in protecting habitats from alien invasions.

Penelope Gottlieb

American
Montanoa Hibiscifolia, from
Invasive Species series, 2012
Acrylic and ink over digitized
Audubon print
36 x 25 in.
Courtesy of the artist

In Penelope Gottlieb's artworks, the introduction of invasive plants into ecosystems devastates wildlife. Seductively beautiful flowers, such as Montanoa hibiscifolia (bush daisy), outcompete native plants that provide food and shelter for other life to flourish.

For her *Invasive Species* series, the artist paints over digitized prints made directly from the first edition of John James Audubon's *The Birds of America*. Sometimes the birds and plants are paired because they live in the same locale; other times, they are grouped together for artistic reasons. Gottlieb's intentional invasion of Audubon prints metaphorically references the suffocating nature of alien species.

In *Montanoa Hibiscifolia* the agitated leaves and flowers of the bush daisy entangle and threaten the survival of a whooping crane. This perennial plant, native to Mexico and Central America, is cultivated in gardens but spreads aggressively through seed distribution.

Gottlieb's appropriation of Audubon's whooping crane is particularly poignant. The species was rescued from the verge of extinction through captive breeding and reintroduction programs. Only fifteen birds remained in 1938, due to unregulated hunting and habitat loss. Today, their scarce numbers (approximately five hundred birds) qualify them for endangered species status. As interpreted by Gottlieb, invasive plants exacerbate the problems faced by many threatened flora and fauna.

Montanoa hibiscifolia

Mark Dion

American, b. 1961
Conquistadors, 1492–1992, 1992
Blueprint, edition of 10
17½ x 23½ in.
Courtesy of the artist and Tanya
Bonakdur Gallery, New York

Mark Dion made *Conquistadors* during the five hundredth anniversary of Christopher Columbus's voyage to the Americas. His blueprint illuminates the enduring legacy of environmental disruption that ensued. The story of slaughtered and suffering indigenous peoples by European newcomers is well known. By contrast, the consequences of their settlements on native animals have been largely ignored.

Conquistadors references the explorer-soldiers who, beginning in the sixteenth century, conquered and exploited territories in the New World for the Spanish and Portuguese Empires. In this print, the domesticated animals brought from Europe occupy center stage. On either side are the major mammals from North and South America displaced by these invaders.

By silhouetting the animals and stacking them by size, Dion creates a graphic work that reverberates today. Domesticated animals worldwide continue to reduce and overwhelm native habitats to the detriment of other forms of life.

POPULATION GROWTH

The power of population is indefinitely greater than the power
in the earth to produce subsistence for man.

—THOMAS MALTHUS, *An Essay on the Principle of Population*, 1798

PABLO LÓPEZ LUZ, *Vista Aerea de la Ciudad de
Mexico, XIII*, 2006. Courtesy of the artist.

Human population growth and expanding cities envelop habitats and consume vast quantities of natural resources. More than 50 percent of the world's population currently clusters in urban centers, with an astounding prediction of 70 percent by 2050.[1] Edward Burtynsky and Yang Yongliang dramatically capture the consequences of this phenomenon.

As rural-to-urban migration continues unabated, sustainable planning remains critical. The greening of cities by providing botanical habitats for humans and wildlife has gained momentum around the world.

Artists are in the forefront of urban ecology, helping to envision greener cities that accommodate people and other forms of life. Patricia Johanson, Daniel McCormick, and Mary O'Brian create modestly scaled eco-art projects that revitalize habitats and conserve precious water in or near cities.

Every day, 227,000 people are added to the planet. The current worldwide population of 7.2 billion is projected to reach 11 billion or more by the end of this century. Consumption will also increase, expanding humanity's ecological footprint (the area of Earth's surface an average person needs to survive). Depleting biodiversity ultimately jeopardizes the survival of our own species, which will force competition for dwindling and degraded food and water supplies.

NOTES

1 See "The Impact of Global Change on Water Resources," United Nations Environmental, Scientific, and Cultural Organization, 2011, http://unesdoc.unesco.org /images/0019/001922/192216e.pdf.

POSITIVE STEPS

- The growing empowerment of girls and women around the world, through education, economic development, and voluntary reproductive healthcare, benefits the human species and the planet.

- The US Forest Service currently supports an urban forest program. See https://www.fs.fed.us/research /urban/wildlife/.

- A growing number of artists work with communities to restore natural spaces and wildlife within cities.

Edward Burtynsky

Canadian, b. 1955
Salt River Pima-Maricopa Indian Community / Scottsdale Arizona, 2011
Digital chromogenic color print
39 x 52 in.
© Edward Burtynsky, Courtesy Metivier Gallery, Toronto / Von Lintel Gallery, Los Angeles

While trying to accommodate the growing needs of an expanding, and very thirsty civilization, we are reshaping the Earth in colossal ways. . . . My hope is that these pictures will stimulate a process of thinking about something essential to our survival; something we often take for granted—until it's gone.

—Edward Burtynsky

Edward Burtynsky starkly contrasts the landscapes of two communities—the city of Scottsdale and the environs of the Pima and Maricopa people—separated by a road. As a microcosm of an escalating crisis, his photograph dramatizes a familiar pattern of urban sprawl in fragile environments.

On one side of an Arizona desert road, intensive use of limited municipal water supplies endangers the future of human inhabitants. On the other side, Native American tribes set aside 35 percent of their land as a nature preserve.

Since the late 1970s, Burtynsky has interpreted humanity's destructive impact on the planet. He researches locations using Google Earth, often finding his final composition while shooting seven hundred feet above ground.

This photograph was featured in Burtynsky's book *Water* (2013), documenting a five-year project that dramatizes the wasteful use of this life-sustaining substance in ten countries. Both the artist's book and his award-winning film *Watermark* offer an eye-opening perspective on humanity's squandering of Earth's most precious resource.

Daniel McCormick and Mary A. O'Brien

American, b. 1950 and 1952
Woven Flood Plain Wall, Carson
River, 2014
Photograph by Mary A. O'Brien
Courtesy of the artists

As artists, we want to do more than just document the changes happening in nature. We want our sculptures to actually play a part in restoring the ecological balance of compromised environments.

—Daniel McCormick and Mary O'Brien

In 2014, Daniel McCormick and Mary O'Brien designed a series of five watershed sculptures along the Carson and Truckee Rivers to restore wildlife habitat, filter water pollutants, and prevent flooding in the expanding human communities near Reno, Nevada. Commissioned by the Nevada Museum of Art's Center for Art + Environment, the artists collaborated with the Nature Conservancy and hundreds of volunteers.

A video, *The Nature of Art*, focuses on the weaving of one of these sculptures that echo the serpentine flow of the river. Made from willow-branch bundles, the work captures silt and water, preventing erosion while nurturing life. Once native vegetation reestablishes itself, the ephemeral artwork decomposes.

McCormick and O'Brien help regenerate a landscape damaged by dredging, agricultural river diversion, and unrestricted grazing. Their work now provides habitat for monarch butterflies and other insects, birds, and small creatures to flourish.

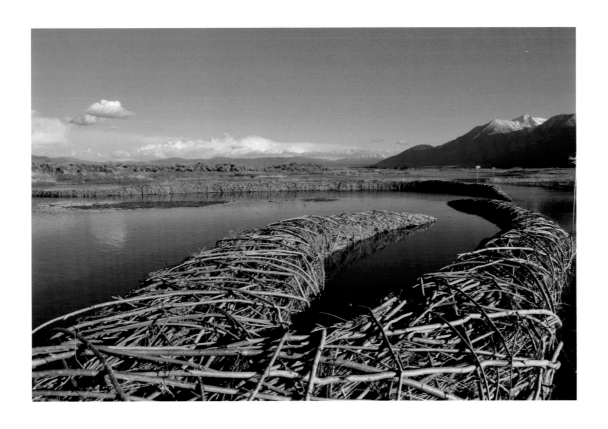

Yang Yongliang

Chinese, b. 1980
Infinite Landscape, 2010
Still from HD video, 7 minutes
Courtesy of the artist

I want to make people reflect. Modern life is comfortable and convenient, but we rarely think about what we exchange for that.

—Yang Yongliang

Yang Yongliang revives the tradition of Song dynasty landscape painting through cutting edge technologies and biting environmental commentary. Compressing up to forty layers of his own photographs and video footage, he creates animations about overpopulation and the loss of an ancient cultural identification with the natural world.

In *Infinite Landscape*, the sacred mountains depicted in traditional paintings morph into skyscrapers, which symbolize China's rapid rise as an industrial power. This process has taken a toll on the country's biodiversity, historic sites, and human health. Ten years ago, 99 percent of the country's 560 million city dwellers breathed polluted air from coal-powered factories.[1] China has since begun to reduce its dependency on this harmful fossil fuel by becoming the largest consumer and exporter of solar technology.

Trained in ancient Chinese calligraphy, Yongliang dramatically interprets the black-and-white graphic qualities of the medium in his video animations. Here two worlds collide, expressing challenging environmental realities in what the artist describes as a more meaningful, contemporary form of communication.

NOTES

1 Joseph Kahn and Jim Yardley, "As China Roars, Pollution Reaches Deadly Extremes," *New York Times*, August 26, 2007, http://www.nytimes.com/2007/08/26/world/asia/26china.html.

Patricia Johanson

American, b. 1940
Linked Gardens (Bobolink) from
House and Garden proposals, 1969
Pencil, ink, and colored pencil on
paper
17 x 22 in.
Courtesy of the artist

Bat Bridge: Crossing Route 24,
1999
Pastel, pencil, ink, and charcoal
on paper
9 x 11½ in.
Courtesy of the artist

Inspired by the male bobolink's distinctive white patches, Patricia Johanson designed a series of native meadows and marshes for birds and people. Her gardens form a connecting corridor of resting places along the bobolink's five-thousand-mile migration route between Argentina and British Columbia.

Wildlife corridors are among the most important solutions to habitat fragmentation. Plans to link expansive ecosystems that support biodiversity are currently underway around the globe, including special bridges along Washington State's Interstate 90 that will benefit North Cascades wildlife.

As early as 1969, Johanson pioneered a form of ecological art that visualized sculptural habitats along highways, in cities and suburban landscapes, even on industrial sites. These visionary designs, commissioned for the magazine *House and Garden* but never published, became the springboard of her life's work.

Bat Bridge is part of Patricia Johanson's master plan for the city of Brockton, Massachusetts, where the artist conceived habitat and wildlife corridors along her proposed Rocky Marciano Trail. Tracing the legendary fighter's running path through his hometown, she recommended linking natural and historic sites that would benefit plants, people, and other animals.

Although the project was never constructed, Johanson's concept of how "green streets restore continuity of ecosystems through urban fabric" reflects her innovative 1969 drawings and remains vitally significant today. Note how the artist's design attends to the smallest creatures such as insects and rodents.

"Linked Gardens" (Bobolink) Patricia Johanson '69

"Bobolink Gardens" — meadows + marshes —
are created to fill gaps along the bobolink's
5000 mile migration route.

British Columbia

Like Pony Express Stations
these gardens serve the
needs of a transient population
while providing enjoyment
for people.

Florida

Gardens are mentally
linked by using the same
access pattern for each
landscape.

Paths are based on
the male bird's
distinctive white
patches.

As the gardens move
from region to region
the marshes +
meadows transform
with the local
landscape.

The arrival of the bobolink
animates each garden with
music on the wing.

home (resting)

path of travel

home

Argentina

BAT BRIDGE
Crossing Route 24
(Brockton)

holes to series of
underground tunnels

shrubs with
berries +
seeds

depression
(fills with
water)

hollow "bat
wing" structures
provide roosting +
hibernation habitat
for bats, birds
+ insects.

flat rocks
provide heat
for rodents
+ ground-dwelling
insects

meadow
grasses

GREEN STREET
transforms into
natural habitats
connecting adjacent
ecosystems

shrubs with
berries + seeds

© Patricia Johanson '99

Patricia Johanson

American, b. 1940
Saggitaria Platyphylla, Fair Park Lagoon, Dallas, Texas, 1985
Photograph by William Pankey
Courtesy of the artist

Saggitaria platyphylla—Planting Plan (Paths, Bridges, Seats and Animal Islands), 1982
For Fair Park Lagoon, Dallas, Texas, 1981–1986
Conte crayon, ink, and pastel on vellum
37½ x 49½ in.
Courtesy of the artist

Fair Park Lagoon is really a swamp—a raw functioning ecology that people are normally afraid of. . . . The art project affords people access to this environment, so they can find out how wonderful a swamp really is.

—Patricia Johanson

Fair Park Lagoon was a near-lifeless environment when the Dallas Museum of Art commissioned Patricia Johanson to create an ecological artwork for the site. Intent on restoring this swamp-like habitat, the artist began by convincing the parks department to cease fertilizing the surrounding lawn. Once the water regained oxygen, she worked with the director of the nearby Dallas Museum of Natural History to introduce native plants and animals that would attract other wildlife to the lagoon.

Johanson's garden plan was inspired by two planted native species—Sagittaria platyphylla (delta arrowhead) and Pteris multifida (spider brake fern)—that suggested the design of intersecting sculptural paths. Her network of walkways protects the shoreline from erosion and provides safe haven for sun-seeking turtles, frogs, and birds. Most importantly, the lagoon welcomes visitors to explore a revived oasis in the heart of the city. A video by Jyoti Duwadi documents the interactions of people with the wildlife that live here.

The future of this pioneering artwork is uncertain.[1] The city of Dallas, which has not properly maintained the park, has fenced off many parts of the sculpture to the public. In 2016, the Dallas City Council began considering plans for a public-private partnership to manage this important urban ecosystem.[2]

NOTES

1 John Revett, "The Fair Park Lagoon, and the Fate of the Fair Park," *Glasstire*, October 2, 2017, http://glasstire.com/2017/10/02/the-fair-park-lagoon-and-the-fate-of-fair-park/.

2 "Council Considers Proposal to Privatize Fair Park," City of Dallas, http://www.dallascitynews.net/council-considers-proposal-privatize-fair-park.

POLLUTION
Land, Water, Atmosphere

The question is whether any civilization can wage relentless war on life without destroying itself, and without losing the right to be called civilized.

—RACHEL CARSON, *Silent Spring*, 1962

GEORGE B. LUKS, *Roundhouse at High Bridge*, 1909–1910, oil on canvas, Munson-Williams-Proctor Institute of Art.

Pollution dates to the earliest human communities involved in economic activities. With smaller populations, contamination was localized. From the dawn of early cities until World War II, pollution was largely centered around the smoke and human waste that fouled air and water.

After World War II, the production of nuclear power and synthetic organic chemicals (containing carbon) changed the magnitude of pollution. Pesticides, fertilizers, plastics, detergents, and more, pervaded every aspect of life. Most recently, computers and smart phones—dependent on the mining of rare earth elements that produce radioactive waste—wind up as trash after limited years of use. Coupled with an increasing human population and accelerating industrial growth, Earth is losing its capacity to absorb all the pollutants generated.

The word "Gaia," referencing the early Greek goddess of Earth, was widely used in the 1980s to describe the planet as a living, breathing, and interconnected organism. People began to understand that the interaction of land, water, and atmosphere ensured that pollution in one area inevitably affected the others.

Artists awaken the public to this devastating problem with the hope of inspiring responsible individual and collective action. The artworks in *Endangered Species* call attention to just a few of the countless effects of environmental contamination on life. Creative approaches to convey this issue are as varied as the sources of pollution itself. Brandon Ballengée, Chris Jordan, David Liittschwager, and Susan Middleton interpret the insidious effects of poisoned air and water on amphibians, birds, and insects. Garth Lenz documents the ravaged landscape of the Alberta tar sands, suggesting the far-reaching effects of fossil fuel production on the biosphere.

POSITIVE STEPS

- In early 2017, the United Nations launched *Clean Seas*, a campaign to end single-use and micro-plastic pollution (products with polyethylene or polypropylene that end up in our drinking water, among other places) by 2020.

- Cities around the world are banning single-use plastics, including bags, disposable cutlery, straws, and bottled water.

- Consumers are buying biodegradable products with less packaging and recycling more, including old electronics.

- More farmers are embracing organic agriculture, and home gardeners are eliminating pesticides.

- Innovations in solar energy and electric-powered vehicles are attracting more consumers and corporations. During a recent two-year period, India installed total solar power equivalent to four-and-a-half Hoover Dams, while China plans to invest $360 billion in the industry over the next three years.

- Individuals can join citizen-science projects that help scientists obtain data on pollution and other matters related to nature and the environment. Watch inspiring stories of people and communities making a difference in the four-part series *The Crowd and the Cloud* on Public Broadcasting Service. Locate and participate in one of sixteen hundred citizen-science projects at http://crowdandcloud.org/.

Garth Lenz

Canadian
Alberta Tar Sands #3, from
*Canada's Tar Sands and the True
Cost of Oil*, 2010
Archival pigment print
40 x 60 in.
Courtesy of the artist

I'm not really there to provide the answer. I think my role as a photographer and artist is to try to ask the question in the most visually evocative and provocative way that one can.

—Garth Lenz

The vastness of the fifty-four-thousand-square-mile Alberta tar sands complex, one of the world's largest fossil fuel extraction sites, is difficult to comprehend. Taking to the air, Garth Lenz documents the scale and destruction of a once-pristine forest ecosystem. Seen here are a few of the tailings ponds that hold toxic waste from the strip mining extraction process. The largest of these waterways is an area 65 percent the size of Manhattan Island and can be seen from space.

Featuring the crisscrossing of roads and ponds colored by poisonous chemicals, Lenz frames an abstract composition that stabilizes the chaotic imprint of human activities. The artist's admiration of modern painting, particularly abstract expressionism, emerges in his spontaneous capture of an image that provokes a potent, visceral response.

Tar sands have formed over millennia in Alberta's ecologically important boreal forest. This large expanse of trees and wetlands is home to wildlife and First Nations communities. Equal to the size of Florida, the forest provides oxygen and sucks up the carbon dioxide that fuels climate change. By contrast, the extraction of tar sands and its subsequent use produces up to three times more global warming emissions than a comparable quantity of conventional crude oil. The effect of mining and drilling in the planet's boreal forests, which contain twice as much carbon as tropical forests, equals a lethal form of air pollution.

Chris Jordan

American, b. 1963
Roundup, 2015
Archival inkjet print, made from
15 colored-pencil drawings of
bees by Helena S. Eitel
60 x 60 in.
Courtesy of the artist

Roundup depicts 213,000 bees, equal to the number of pounds of toxic chemical pesticides applied to plants and soils around the world every 20 minutes. Over 1 billion pounds of pesticides are introduced into the environment in the US each year, and approximately 5.6 billion pounds are used worldwide.

—Chris Jordan

Chris Jordan's unique portraits of human consumption and their connection to pollution helps people grasp the magnitude of environmental statistics. In *Roundup*, the artist configures thousands of bees into a mandala, a circular diagram that evokes spirituality in many faith traditions. Equating this insect with a cosmic symbol deepens the artist's commentary on the declining bee populations.

Important crop pollinators, bees are suffering worldwide, due in part to pesticides. The commercial herbicide Roundup contains glyphosate, a chemical classified as a probable cancer-causing agent by the United Nations World Health Organization. It is just one of the many chemical substances toxic to plants and animals, including monarch butterflies that depend exclusively on the nectar of disappearing milkweeds.

In 2017, a study of sixty-three protected habitats in Germany noted a 76 percent decline in flying insects over a period of twenty-seven years, between 1989 and 2016. Many of these sites were contiguous with agricultural landscapes.[1]

We can only infer from Jordan's *Roundup* that glyphosate endangers more than insects. In fact, chemical residues have been discovered in eggs, cookies, flour, beer, and infant formula. A recent book by Casey Gillam, *Whitewash: The Story of a Weed Killer, Cancer, and the Corruption of Science* (2017), documents how this common pesticide permeates the environment.

NOTES

1 Casper A. Hallmann et al., "More than 75 Percent Decline over 27 Years in Total Flying Insect Biomass in Protected Areas," *PLoS ONE* 12 (October 18, 2017), https://doi.org /10.1371/journal.pone.0185809.

Susan Middleton and David Liittschwager

American, b. 1948 and 1961
Contents of Laysan Albatross Stomach and *Laysan Albatross Necropsy (moli Phoebastria immutabilis)*, 2004
Archival pigment print
30 x 60 in.
Courtesy of the artists

The planet is drowning in plastics. A million birds and more than one hundred thousand sea mammals and turtles die each year, hidden from view. In this paired photograph, Susan Middleton and David Liittschwager reveal a harrowing still life of death: An albatross chick is unknowingly fed plastic by its parents, who scoop food from the currents along the ocean surface. Middleton arranges the contents of its stomach to inventory a colorful array of items—cigarette lighters, bottle caps, an aerosol pump top, a piece of a shotgun shell, broken toys, clothespins—each used by humans for a moment in time.

Over eight billion metric tons of plastics have been produced since its introduction in the 1950s.[1] Each year, millions of tons enter the ocean, accumulating in giant patches called gyres. As plastics do not decompose, they often wash up on beaches as haunting reminders of humanity's legacy of waste. Recent studies confirm that imperceptible particles of microplastics found in cosmetics and clothing have now insidiously infiltrated human drinking water around the world.

This image belongs to a series of collaborative photographs published in the *National Geographic* book *Archipelago: Portraits of Life in the World's Most Remote Island Sanctuary* (2005). Middleton and Liittschwager, after working with the pioneering fashion and portrait photographer Richard Avedon, established a compelling style of portraying endangered species in such books as *Here Today: Portraits of Our Vanishing Species* (1991) and *Witness: Endangered Species of North America* (1994).

NOTES

1 Roland Geyer, Jenna R. Jambeck, and Kara Lavender Law, "Production, Use, and Fate of All Plastics Ever Made," *Science Advances* 3, no. 7 (July 19, 2017), http://advances.sciencemag.org/content/3/7/e1700782.full.

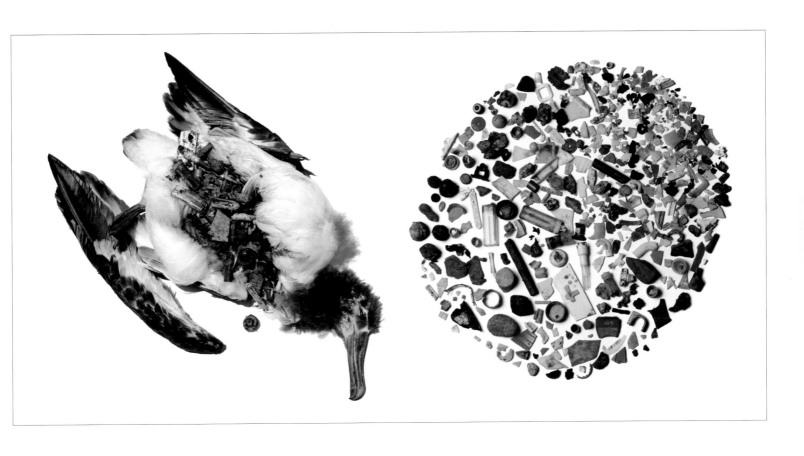

Brandon Ballengée

American, b. 1974
DFB 39 Priapus, 2013, from the
series *Malamp: The Occurrence of
Deformities in Amphibians*
Cleared and stained Pacific
tree frog collected in Aptos,
California, in scientific
collaboration with
Stanley K. Sessions
Unique Iris print on Arches
watercolor paper
46 x 34 in.
Courtesy of the artist and Ronald
Feldman Fine Arts, New York

That's the contradiction of these artworks; it's the reality of
our backyard, but it seems so supernatural.

—Brandon Ballengée

The growing number of deformities in the world's diminishing amphibian populations has fascinated artist-biologist Brandon Ballengée since 1996. His laboratory research and field work spawned a series of prints conceived as reliquaries, shrines to the remains of once-thriving animals.

In this composition, the artist floats a Pacific tree frog with an extra leg and misaligned body in stellar space, becoming an alien outcast from another world. Named after Priapus, an ancient fertility god represented in sculpture with an over-sized phallus, the work metaphorically references a class of animals whose offspring are at risk.

Sensitive to pollution due to their thin skins, amphibians (frogs, toads, and salamanders) are among the most globally endangered animals. Although the Pacific tree frog is currently not listed as threatened, the artist found deformed frogs like *Priapus* in a California wetland.

Amphibians are excellent indicator species because of their ability to live on both land and water. They call attention to both subtle and radical environmental changes. In addition to pollutants, these animals are also victims of habitat loss, infectious disease worsened by climate change, and the introduction of exotic species. The ghostly appearance of *Priapus* reflects the plight of frogs worldwide.

Ballengée reveals the deformities in frogs through a lengthy and complex process that combines biology, chemistry, and high-tech scanning equipment. After dissolving the frog's thin flesh, he injects his specimen with dyes that stain bones and cartilage.

The artist's practice also incorporates eco-actions, field trips that engage students with the biology of wetlands. By connecting art and science through specimen collecting, photography, drawing, and creating aquaria, Ballengée inspires a sense of environmental stewardship. In turn, student contributions as citizen scientists inform his interdisciplinary work.

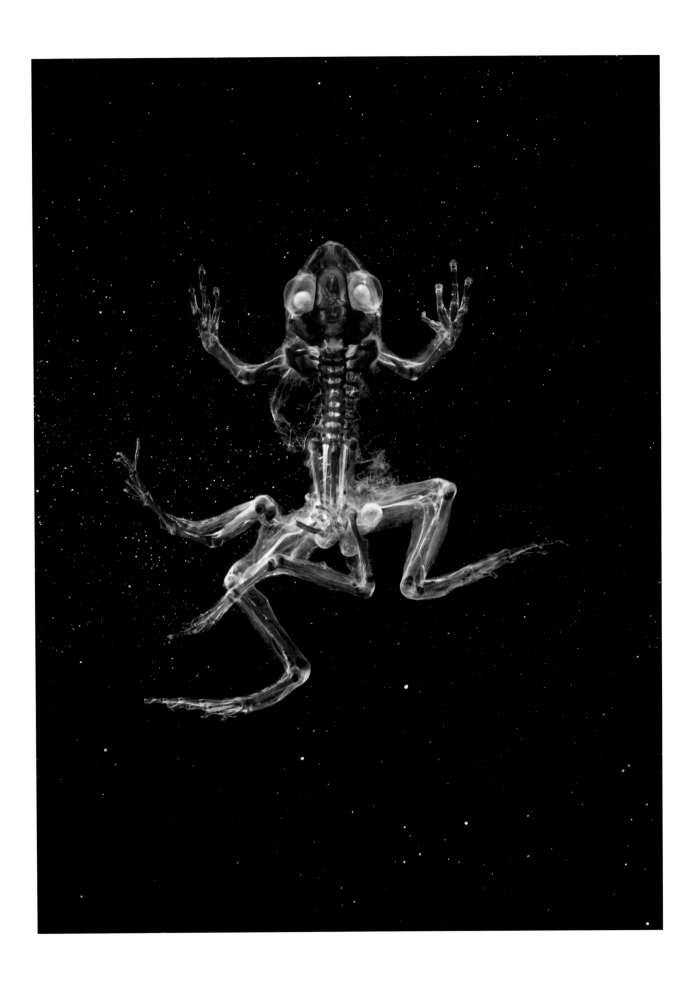

OVERHARVESTING
Unsustainable Hunting and Fishing

All Nature is linked together by invisible bonds and every
organic creature, however low, however feeble, however dependent,
is necessary to the well-being of some other among the myriad
forms of life.

—GEORGE PERKINS MARSH, *Man and Nature*, 1864

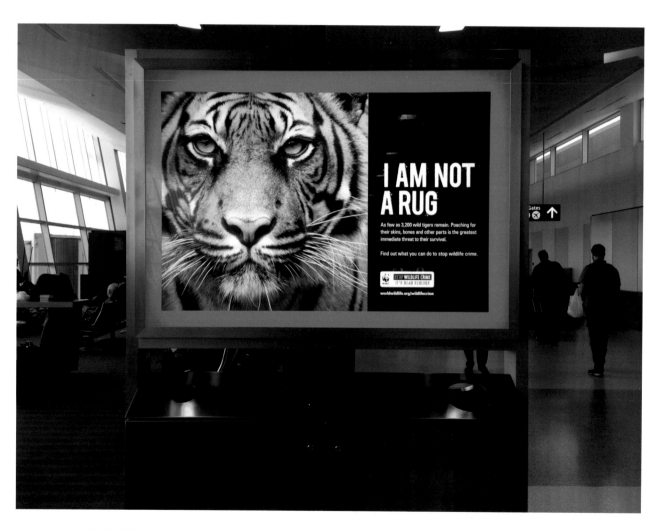

I am not a Rug, World Wildlife Fund campaign,
Seattle-Tacoma International Airport, 2015.

In the past, most human-induced extinctions have been attributed to over-exploiting animals—the dodo and the great auk, among others—for consumption. Today, an expanding human population has triggered a rapid decline of species worldwide through unsustainable hunting and fishing practices.

Photographers David Chancellor and Brian Skerry dramatically shock us into paying attention to this critical issue. The harvesting of wild species at rates faster than their populations can recover destroys biodiversity. It also threatens the survival of humans, who find it ever more difficult to nourish themselves.

On Land

Overharvesting includes the unregulated and often illegal hunting and trading of bushmeat from wild mammals, reptiles, amphibians, and birds. Sixty percent of Earth's largest mammals, including primates such as gorillas, are at risk of extinction from overhunting.

Overharvesting also involves the poaching of animals whose parts are used for medicine and ornament. Trophy hunting as a commodity, captured by David Chancellor, and the trade in exotic pets join the list of human activities that contribute to endangered species.

Overhunting sparks a cascade effect that depletes ecosystems. For example, the hunting of monkeys and tapirs for food jeopardizes the Amazon rainforest, which depends on these animals to distribute the seeds of its large trees.

At Sea

According to the United Nations Food and Agriculture Organization, 90 percent of the world's fish populations are either close to the maximum sustainable yield (60 percent) or overexploited (30 percent). These numbers reflect unsound practices such as bottom trawling, exposed by Brian Skerry, and industrial fishing. The World Bank estimates that a temporary reduction in fishing to allow recovery, in conjunction with better management, could generate an additional $83 billion for fisheries.[1]

NOTES

1 "Giving Oceans a Break Could Generate US$83 Billion in Additional Benefits for Fisheries," press release, World Bank, February 14, 2017, http://www.worldbank.org/en/news/press-release/2017/02/14/giving-oceans-a-break-could-generate-83-billion-in-additional-benefits-for-fisheries.

POSITIVE STEPS

- The Convention on International Trade in Endangered Species of Wild Fauna and Flora (CITES) works with governments in controlling the import and export of thirty-three thousand listed species. Elephant ivory and, most recently, shark fins have been targeted.

- Marine Protected Areas have been established to prohibit some or all economic activities. Fishing was recently banned in six hundred thousand square miles of Antarctica's Ross Sea and Mexico's fifty-seven-thousand-square-mile Revillagigedo Archipelago, the largest ocean reserve in North America.

- In the United States, the Magnuson-Stevens Fishery Conservation and Management Act prevents overfishing by regulating sustainability in waters three to two hundred miles from land.

- Consumers can select seafood from well-managed fisheries using a guide designed by The Monterey Bay Aquarium.

Brian Skerry

American, b. 1961
*Bycatch—In a cascade of death,
guitarfish, bat rays, founder,
puffers, and other bycatch are tossed
from a shrimp boat in the Gulf of
California, Mexico,* 2005
C-print
32 x 48 in.
Courtesy of the artist

The oceans are in trouble. There are some serious problems out there that I believe are not clear to many people. My hope is to continually find new ways of creating images and stories that both celebrate the sea yet also highlight environmental problems. Photography can be a powerful instrument for change.

—Brian Skerry

After reading that 90 percent of the ocean's big fish have disappeared in the last fifty years, Brian Skerry pitched a photographic essay to *National Geographic* that would call public attention to this tragedy. *Bycatch* was one of many riveting pictures featured in "Still Waters: The Global Fisheries Crisis," the magazine's cover story in April 2007.

Skerry photographs a bottom trawler, one of the world's most common types of fishing vessels. These boats are also the most environmentally destructive. Their dragging nets destroy coral reefs and capture less commercially valuable fish. Swimming underneath a shrimp trawler, Skerry documents a fisherman shoveling bycatch—the dead fish discarded as trash—into the sea. This photograph presents the true cost of a shrimp dinner.

For the past thirty-five years, Skerry has revealed both the ocean's magical biodiversity in New Zealand's marine protected areas and the horrific human treatment of life within an ecosystem hidden from our sight. In *Sharks: On Assignment with Brian Skerry* at the National Geographic Gallery (2017), the artist conceived his exhibition to catalyze protection of the one hundred million sharks killed each year for their fins.

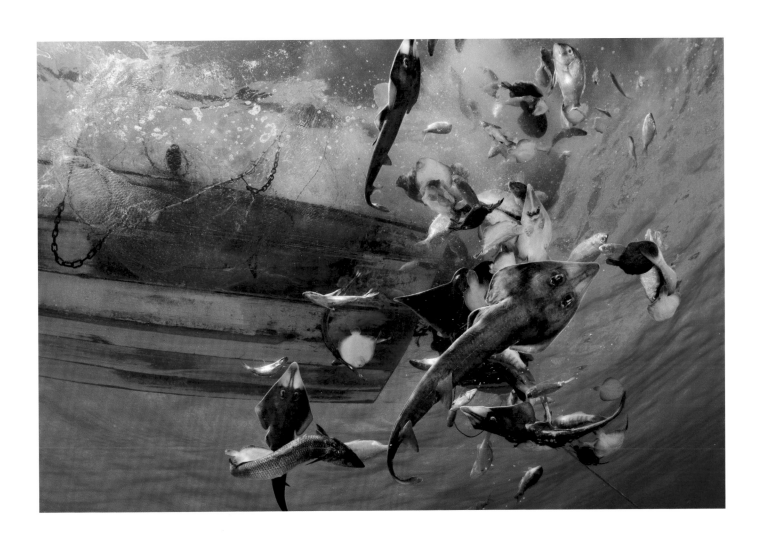

David Chancellor

British, b. 1961
Untitled Hunter #1, Trophy Room,
Dallas, Texas, 2011,
from *Hunters,* 2013
Chromogenic print
54 x 34 in.
Courtesy of the artist

From day one I realized that this wasn't, and isn't, about the rights and wrongs of hunting. This work is about the commodification of wildlife. . . . What I found with this work was a "wildlife industry" that responds to man's demands as best it can, and what man demands, he shall have.

—David Chancellor

An unnamed hunter takes his place among a menagerie of taxidermy animals in this photograph by David Chancellor. Collecting the most highly prized endangered animals qualifies the hunter for coveted achievement awards. This recognition of human prowess guarantees high status in the Dallas Safari Club, a six-thousand-member organization that ironically links the rights of hunters to kill wildlife with the conservation of these animals.

Trophy hunting is big business. In Zimbabwe, a single hunter can spend more than US$40,000 on a trophy hunting trip. Chancellor documents what has become known as "canned hunting," pursuing animals that are bred, raised, and held in captivity exclusively for the pleasure of wealthy sportsmen. Private hunting ranches in twenty-three African countries control more than 540,000 square miles of land, amounting to 22 percent more land than is protected by national parks.[1]

This photograph is included in Chancellor's book *Hunters* (2013), which offers an extraordinary look into the culture of South African trophy hunting. The book includes sections on hunters, the hunted, and Dallas Safari Club.

NOTES

[1] Sabrina Bosiacki, "Let's Talk Solutions! How to Manage Sport Hunting and Benefit Conservation," Global Wildlife Conservation Group, University of Texas Austin, December 15, 2014, https://sites.utexas.edu/wildlife/2014/12/15/lets-talk-solutions-how-to-manage-sport-hunting-and-benefit-conservation/.

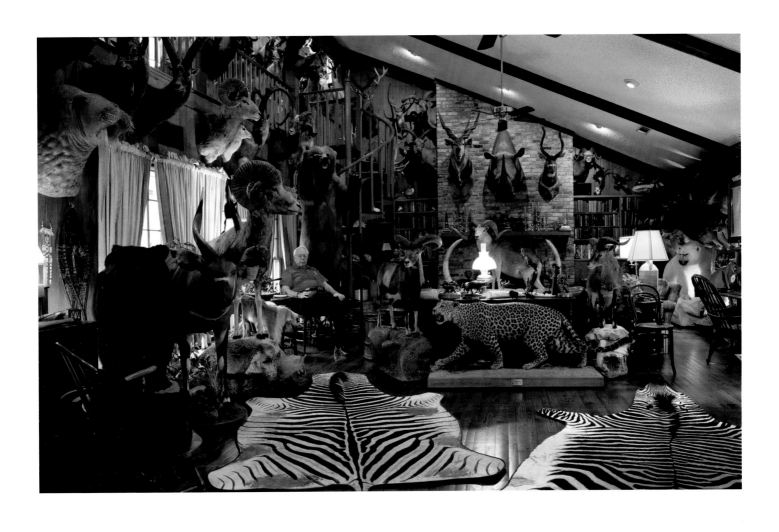

THE PROMISE OF SEED BANKS
Preserving Botanical Diversity

Few things on Earth are as miraculous and vital as seeds. Worshipped and treasured since the dawn of humankind, these subtle flecks of life are the source of all existence. Like tiny time capsules, they contain the songs, sustenance, memories, and medicines of entire cultures. They feed us, clothe us, and provide the raw materials for our everyday lives. In a very real sense, they are life itself.

—From the film *Seed: The Untold Story*, 2016

DORNITH DOHERTY, *Antique Seed Collection, Threatened Flora Seed Center, Kensington, Western Australia*, 2013.

Seed banks help maintain botanical diversity. In response to habitat loss and the planet's changing climate, they preserve the genetic information of wild and agricultural plants. Biologists estimate that sixty thousand to one hundred thousand species, representing 25 percent of the plant kingdom, are currently at risk of extinction.[1]

Six million seeds have already been collected, stored, and banked in more than thirteen hundred private and government-sponsored vaults. Stored at low temperatures, or sometimes frozen, seeds can germinate up to two hundred years later. Some repositories, such as the Millennial Seed Bank in England, plant and harvest the seeds of thirty-three thousand species every ten years to ensure their survival.

Ninety-four percent of our food seed varieties disappeared during the twentieth century. Large seed banks represent one solution to mitigate this trend. Thankfully, individuals around the world have devoted their lives to preserving heirloom seeds.

This pioneering grass-roots movement inspired the film *Seed: The Untold Story* (2016), which showcases efforts to protect humanity's twelve-thousand-year-old food legacy. By protecting and reintroducing heritage seeds into agriculture, people counter the influence of biotech chemical companies who control the majority of the world's seed supply through privatization and patents. From a cultural perspective, artists such as Dornith Doherty contribute to the conservation of botanical diversity by calling attention to this critical solution.

NOTES

[1] According to the Royal Botanic Gardens, Kew. See https://www.kew.org/science/collections/seed-collection. An article by Damian Carrington in the *Guardian* (May 9, 2016) also indicated that two thousand new species are discovered each year, underscoring the need to preserve habitat. See "One in Five of World's Plant Species at Risk of Extinction," https://www.theguardian.com/environment/2016/may/10/one-in-five-of-worlds-plant-species-at-risk-of-extinction.

Dornith Doherty

American, b. 1957
*Millennium Seed Bank Research
Seedlings and Lochner-Stuppy Test
Garden No. 3*, 2011
Digital chromogenic lenticular
photograph
79 x 36 in.
Courtesy of the artist

I am struck by the power of these tiny plantlets and seeds (many are the size of a grain of sand) to generate life and to endure the time span central to the process of seed banking, which seeks to make these sparks last for two hundred years or more.

—Dornith Doherty

Working with biologists, Dornith Doherty interprets specimens archived at seed banks in the United States, Great Britain, and Australia. In this photograph, the artist highlights seeds and plantlets stored at the Millennium Seed Bank of the Royal Botanic Gardens, Kew. The world's largest seed repository, it plans to preserve 25 percent (seventy-five thousand species) of Earth's wild plants by 2020.

Doherty photographs the promise of new beginnings using the seed bank's laboratory x-ray equipment. Radiation makes visible the hidden forms within seeds and plant tissues. She then digitally collages these images in her studio and conjures glowing, ghostly forms silhouetted against indigo blue backgrounds. They are printed and mounted on lenticular lenses that impart the illusion of depth and motion as color changes from green to blue.

This work belongs to *Archiving Eden,* an eight-year project and book that also includes photographs documenting the storage vaults of these "libraries of life." The series was inspired by the completion of the Arctic's Svalbard Global Seed Vault, the world's largest repository of agricultural plants housing 1.5 billion seeds.

Doherty builds upon the tradition of microphotography pioneered by Carl Strüwe and Roman Vishniac. Celebrating life while lamenting its loss, she contributes a critical awareness of humanity's impact, both positive and negative, on biodiversity.

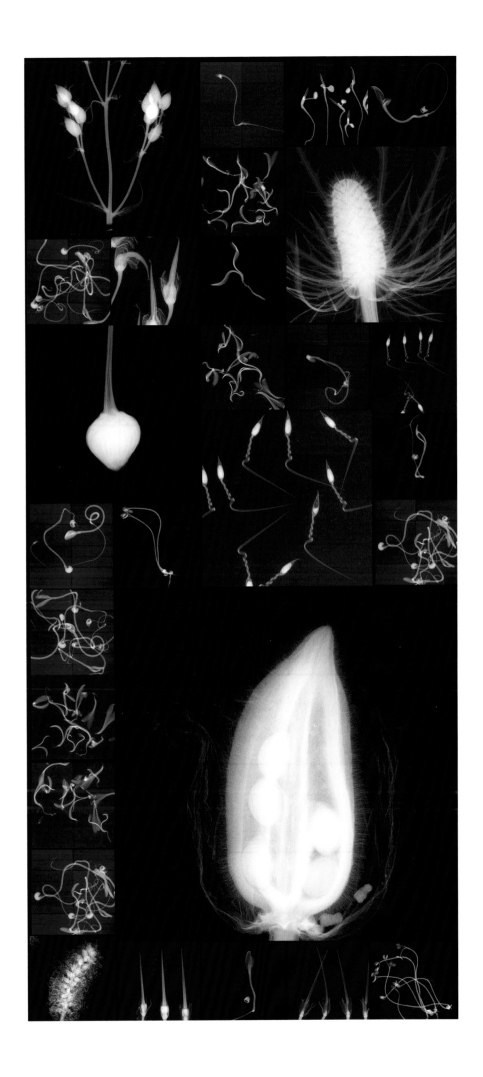

TIMELINE
Conservation Milestones

Examine each question in terms of what is ethically and
esthetically right, as well as what is economically expedient.
A thing is right when it tends to preserve the integrity,
stability, and beauty of the biotic community. It is wrong
when it tends otherwise.

—ALDO LEOPOLD, Sand County Almanac, 1949

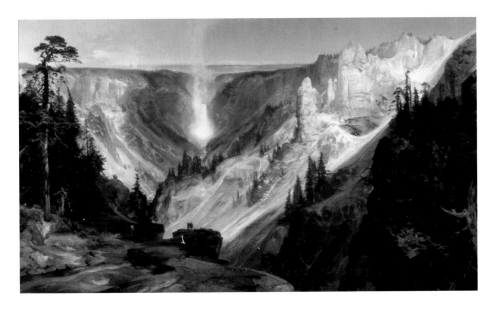

THOMAS MORAN, *Grand Canyon of the Yellowstone,* 1872, oil on canvas, 84 x 144 in. Smithsonian American Art Museum, Lent by the Department of the Interior.

1826–1838 Artist John James Audubon publishes the first edition of *Birds of America,* with hand-colored images of more than seven hundred birds.

1832 Artist George Catlin proposes a "nation's park" for buffalo and indigenous people after visiting the West and observing Native American tribal cultures.

1845–1847 Henry David Thoreau lives at Walden Pond, Massachusetts, and writes his book *Walden; or, Life in the Woods,* published in **1854**.

1849 The US Department of the Interior is established to protect and manage "the Nation's natural resources and cultural heritage."

1859 Construction of New York City's Central Park begins, ushering in a new era of public park creation in the United States.

1864 The US government cedes Yosemite Valley and nearby Mariposa Big Tree Grove to the state of California " for public use, resort, and recreation."

George Perkins Marsh publishes *Man and Nature,* a seminal book about the negative effects of deforestation.

1872 Inspired by William Henry Jackson's photographs and Thomas Moran's paintings, Congress designates Yellowstone as both the nation's and the world's first national park.

A tree-planting day is celebrated in Nebraska. By the mid-**1880s**, what is now known as Arbor Day is observed in every state.

1873 *Forest and Stream* magazine is founded, becoming the premiere sportsman's publication and a forum for conservation advocacy.

1874 William Cullen Bryant's *Picturesque America* is published. The book's full-page engravings of some of the country's most celebrated scenery, such as Niagara Falls, stimulate popular interest in the natural landscape.

1875 The American Forestry Association is founded. Congress passes an act prohibiting the unauthorized cutting of trees on government property.

1876 John Muir writes about preservation of Sierra Nevada's giant sequoia trees, inspiring the National Parks bill in **1890** that creates Yosemite, Sequoia, and General Grant National Parks.

The Appalachian Mountain Club is founded in Boston, Massachusetts, to protect the mountains, rivers and trails of the northeastern United States. The club remains the nation's longest-running conservation organization.

1885 New York's Adirondack Forest Preserve is created, becoming a state park in **1892.** Containing 2.7 million acres, it is the largest protected state or federal forest zone in the continental United States.

New York opens Niagara Falls State Reservation, the first state park in the eastern United States.

1887 George Bird Grinnell and Theodore Roosevelt establish the Boone and Crockett Club, which advocates for conservation and "ethical hunting."

1889 William Temple Hornaday, chief taxidermist of the United States National Museum, publishes "Extermination of the American Bison" in the Smithsonian Institution's *Report of the National Museum.*

1891 The US Forest Reserve Act, which empowers the president to set aside public reservations, initiates the National Forest System.

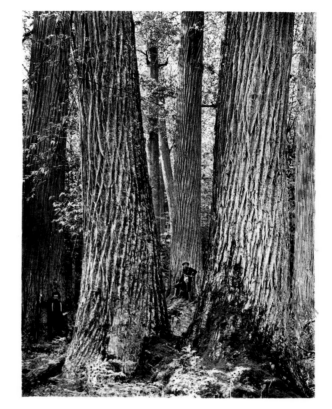

Old-growth chestnut tree, Great Smoky Mountains, North Carolina, 1909-1910. Courtesy of Forest History Society, Durham, North Carolina.

1892 The Sierra Club, dedicated to wilderness preservation and outdoor recreation, is founded. John Muir is elected president, a post he holds for twenty-two years.

1898 Gifford Pinchot becomes head of the US Division of Forestry. Over the next twenty years, he promotes scientific forestry and leads the utilitarian wing of the conservation movement.

1899 Congress passes a bill creating Mount Rainier National Park in Washington State.

1900 The Lacey Act becomes the first US federal conservation law to prohibit trade in wildlife, fish, and plants that have been illegally taken, possessed, transported, or sold.

1901 Theodore Roosevelt becomes president of the United States and supports conservation as a domestic priority.

1903 President Roosevelt establishes a federally protected wildlife refuge at Pelican Island, Florida. It is the first of fifty-three refuges he creates, setting a precedent for today's National Wildlife Refuge System.

1904 Chestnut tree blight is introduced to North America via a popular Japanese import, the Japanese chestnut. By **1940**, most mature American chestnut trees are wiped out.

1905 William Temple Hornaday and President Roosevelt form the American Bison Society and create the National Bison Range in Montana, where a herd of thirty-nine bison grows to approximately four hundred bison by **2017**.

President Theodore Roosevelt increases US Forest Service land from forty million to two hundred million acres, after transferring responsibility for US forests from the Department of the Interior to the newly created National Forest Service.

The National Association of Audubon Societies for the Protection of Wild Birds and Animals (National Audubon Society) is founded.

1906 The US Antiquities Act is signed into law by President Roosevelt and allows the president to reserve ancient Indian artifacts and significant historic sites as national monuments, including Devil's Tower, Grand Canyon, and Petrified Forest.

1912 The Plant Quarantine Act establishes government powers to inspect shipments of suspected invasive species.

1913 William Temple Hornaday, head of the New York Zoological Park, publishes *Our Vanishing Wild Life: Its Extermination and Preservation*, one of the first books devoted to endangered animals.

1914 The passenger pigeon, once the most abundant bird in North America, becomes extinct.

1916 The National Parks Service is established to "conserve the scenery and the natural and historic objects and the wildlife therein and to provide for the enjoyment of same in manner and by such means as will leave them unimpaired for the enjoyment of future generations."

The private philanthropy of John D. Rockefeller Jr. helps establish what becomes Maine's Acadia National Park, the first national park east of the Mississippi River.

1918 The Migratory Bird Treaty Act, between the United States and Canada, makes it unlawful to hunt, kill, capture, or sell listed birds. Enacted in response to the commercial trade in birds and feathers, the list includes eight hundred species as of **2017**.

1919 Congress passes a bill establishing Grand Canyon National Park in Arizona and Zion National Park in Utah.

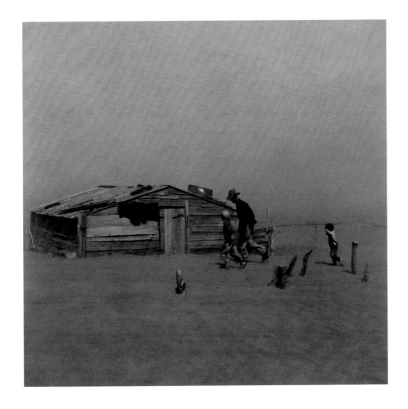

ARTHUR ROTHSTEIN, *Dust Storm, Cimarron County, Oklahoma,* 1936, black-and-white photograph. US Farm Security Administration Collection, Library of Congress.

1921 Pioneering regional planner, Benton MacKaye, proposes a trail and wilderness belt along the mountain ranges of the eastern United States. His vision later becomes the two-thousand-mile Appalachian Trail, completed in **1937**.

1929 The United States passes the Migratory Bird Conservation Act, enabling the federal government to purchase land in order "to conduct investigations, to publish documents related to North American birds, and to maintain and develop refuges."

1931 Severe drought hits the midwestern and southern plains in the United States, now known as the Dust Bowl. Winds, whipping over-plowed and over-grazed land, last until **1939.**

1933 The Civilian Conservation Corps (CCC) is established as part of President Franklin Delano Roosevelt's New Deal. During the Great Depression, the CCC employs half a million young men to work on public projects to improve the country's national, state, and local parks and forests.

1934 The Duck Stamp Act is passed by Congress, requiring each waterfowl hunter to purchase a stamp, thereby generating revenue for wetland acquisition. The Act has resulted in 4.5 million acres of waterfowl habitat protection.

1936 The General Wildlife Federation is founded. Its name is changed to National Wildlife Federation in **1938**.

1939 The US Department of the Interior creates the Fish and Wildlife Service, which is dedicated to the conservation of natural resources.

The Carolina parakeet, the only parrot species native to the eastern United States, becomes extinct.

1947 Marjorie Stoneman Douglas's landmark book is published. *The Everglades: River of Grass* culminates a twenty-year effort to educate the public and political leaders about the importance of this unique ecosystem. Everglades National Park is established at the same time.

1948 The International Union for the Protection of Nature is created, bringing together governmental bodies and nongovernmental organizations to protect natural heritage through policy initiatives and on-the-ground actions. The organization's name is later changed to International Union for Conservation of Nature (IUCN).

1949 Aldo Leopold's *A Sand County Almanac* is published. Among the most influential books about conservation ever written, it urges the need for a "land ethic."

1951 The Nature Conservancy is created by its predecessor, the Ecologist's Union. By the 1990s this organization owns and manages the largest network of private nature reserves in the world.

1955 The US Air Pollution Control Act is enacted by Congress, declaring air pollution the responsibility of state and local governments.

1956 The US Fish and Wildlife Act, a comprehensive national fish, shellfish, and wildlife resources policy, is established.

1961 The World Wildlife Fund (WWF) is founded.

Gaylord Nelson Jr., a senator of Wisconsin, initiates the Outdoor Recreation Act Program (ORAP), which includes a one-cent tax on cigarettes that generates $50 million for acquiring one million acres of state land for recreation and preservation.

Front page of the *New York Times*, Thursday, April 23, 1970.

1962 Rachel Carson publishes her book *Silent Spring*, which ignites the campaign against toxic chemicals. The book launches a new era of growth in environmental awareness and activism, leading to the ban of the pesticide DDT in the United States in **1972**.

1963 Secretary of the Interior Stewart Udall publishes *The Quiet Crisis*, a book concerning the dangers of pollution, dwindling natural resources, and limited space.

1964 The Wilderness Preservation Act is signed into law to prohibit mining, timber cutting, and other operations from designated areas. The law currently protects 110 million acres in 757 sites.

1965 US Congress passes the Land and Water Conservation Fund Act.

1968 US Congress passes the National Wild and Scenic Rivers Act and the National Trails Act.

1969 The Santa Barbara oil spill occurs. It is the largest oil spill in United States waters at the time.

The National Environmental Policy Act is created "to assure that all branches of government give proper consideration to the environment prior to undertaking any major federal action that significantly affects the environment." It becomes the prototype for similar legislation in more than one hundred countries.

1970 On April 22, twenty million people participate in the first Earth Day demonstration.

President Nixon creates the US Environmental Protection Agency (EPA) to enforce laws protecting the environment and public health.

1972 The Clean Air and Clean Water Acts are passed and implemented by the EPA.

The United Nations Environmental Programme (UNEP) is established. Governments sign an international agreement to regulate trade of endangered species.

The World Heritage Convention is adopted by the United Nations Educational, Scientific and Cultural Organization (UNESCO). This treaty encourages the identification and protection of outstanding cultural and natural heritage sites around the world.

1973 The US Endangered Species Act is signed and implemented by the EPA.

1976 The US Toxic Substances Control Act and National Forest Management Act are signed into law and implemented by the EPA.

The Magnuson-Stevens Fishery Conservation and Management Act (Magnuson-Stevens Act) becomes the primary law governing marine fisheries management in US federal waters. It prevents overfishing and encourages sustainability.

1977 The first plant species are listed as endangered under the US Endangered Species Act, including the San Clemente Island Indian paintbrush, larkspur, broom, and bush mallow.

1978 Lois Gibbs and residents of Niagara Falls, New York, form the Love Canal Homeowners' Association to fight against toxic contamination by the Hooker Chemical Corporation. Their efforts secure a cleanup and compensation for area residents. The association sparks grassroots environmental activism across the country and generates momentum for national legislation to deal with hazardous wastes.

1980 The US Superfund Act, which designates toxic sites and provides funding for cleanup, becomes law and is implemented by the EPA.

1980s Dutch elm disease claims seventy-seven million trees.

As a decade of rainforest destruction unfolds, fifty thousand square miles of habitat are lost each year. The crisis leads to the growth of international environmentalism. The World Resources Institute (WRI) is founded in **1982**, followed by Conservation International in **1987**.

1986 The catastrophic nuclear accident known as the Chernobyl disaster occurs in the Ukraine.

1986 The Mexican government creates an ecological reserve where one hundred million monarch butterflies converge each winter.

CHRISTO, "Planet of the Year: Endangered Earth," cover for *Time* magazine, January 2, 1989.

1987 The Rainforest Action Network (RAN) organizes a boycott of Burger King, which results in the cancellation of Central American rainforest beef contracts.

1987 The Montreal Protocol is signed by twenty-four nations, including the United States, agreeing to phase out production of chlorofluorocarbons, known to destroy the ozone layer, a problem first detected in **1985**.

Our Common Future, a report of the World Commission on Environment and Development, popularizes the concept of sustainability and concludes that economic development must become less ecologically destructive.

1988 The United Nations creates the International Panel on Climate Change (IPCC).

Chico Mendes, who fought to preserve the Amazon rainforest and advocated for human rights, is murdered.

1989 *Time* magazine's January issue, "Planet of the Year," portrays an "Endangered Earth" wrapped in plastic and string, courtesy of the artist Christo.

A global ivory ban is enacted by the Convention on International Trade in Endangered Species of Wild Fauna and Flora (CITES) to reduce poaching and protect elephants.

1990s Nongovernmental organizations play an increasingly important role in conservation worldwide. More than twelve hundred land trusts are active in the United States by the late 1990s, an increase of 63 percent from a decade earlier. Together, the trusts now protect nearly five million acres.

1990 The northern spotted owl is listed as threatened under the US Endangered Species Act, which leads to the development of the Northwest Forest Plan to govern land on federal lands of the Pacific Northwest.

1992 The United Nations Convention on Biological Diversity pledges to support all life on Earth.

The largest meeting of world leaders, the United Nations Conference on Environment and Development ("Earth Summit"), takes place in Rio de Janeiro, Brazil. A historic set of agreements are signed: the Convention on Climate Change, which targets industrial and other emissions of greenhouse gases; and the Convention on Biological Diversity, the first global agreement on the conservation and sustainable use of biological diversity. All the countries of the world except the United States ratify this agreement.

1993 World Wildlife Fund completes a $19 million debt-for-nature swap in the Philippines. The trade is the largest ever undertaken by a nongovernmental organization.

1995 The gray wolf is reintroduced into Yellowstone National Park and central Idaho.

1997 The Kyoto Protocol is signed by thirty-eight industrialized nations to reduce their greenhouse gas emissions by 5 percent over fifteen years. The United States, which has the world's highest emissions, agrees to reduce by 7 percent.

Several Canadian oil companies donate 320,000 acres of exploration rights off Canada's Pacific Coast to establish the Gwaii Haanas National Marine Conservation for orcas, sea otters, starfish, and hundreds of other marine species.

1998 In a pledge with the WWF–World Bank Alliance, the president of Brazil commits to providing legal protection for 10 percent of Brazil's rain forests.

1999 World Wildlife Fund and Fundacion Vida Silvestre Argentina help to win passage of legislation protecting a 2.5 million-acre forest corridor connecting existing reserves in Argentina's Misiones Province and neighboring Brazil.

2001 The US Forest Service, under President Clinton, halts harvesting of old-growth timber on public lands.

President Bush refuses to re-sign the Kyoto Protocol to reduce climate change by reducing the release of heat-trapping greenhouse gases. The agreement is signed by 141 other nations.

In the Eastern Himalayan lowlands, World Wildlife Fund spurs progress toward creating wildlife corridors linking eleven protected areas between Nepal's Royal Chitwan National Park and India's Corbett National Park.

This logo is used by the conservation group WildEarth Guardians to promote protection of one of our country's foundational environmental laws.

PROTECT THE LAW THAT PROTECTS US

THE ENDANGERED SPECIES ACT

WWW.WILDEARTHGUARDIANS.ORG

2006 *An Inconvenient Truth*, a documentary film about global warming written by and starring Al Gore, gains international recognition.

2008 The polar bear is the first species listed as threatened due to habitat loss in the Arctic from climate change.

2008 The Lacey Act is amended to include plants.

2009 The United Nations REDD program (Reducing Emissions through Deforestation and Forest Degradation) offers monetary and technical assistance to mitigate climate change.

2011 The Fukushima Daiichi nuclear disaster occurs as a result of an energy accident initiated by a tsunami. Germany and Taiwan accelerate plans to close their nuclear power industry.

2013 Thailand's prime minister pledges to end domestic ivory trade in his country.

2014 The United Nation's Intergovernmental Panel on Climate Change (IPCC) releases an alarming report that predicts the dire environmental and economic consequences of climate change around the world if the world's leading economies don't begin reducing greenhouse gas emissions immediately.

2015 The Paris Agreement within the United Nations Framework Convention on Climate Change (UNFCC) is negotiated and signed by 195 countries. Each country determines the contribution it should make to mitigate climate change.

2017 China, the world's largest ivory market, begins implementing a trade ban on elephant tusks.

President Trump's administration begins taking several actions which could jeopardize Earth's biodiversity, including the following:

The 2018 federal budget calls for a 31 percent cut in the EPA budget, a 12 percent cut in the Department of the Interior, and a 6 percent cut in the Department of Energy.

The administration withdraws from the Paris climate agreement, in which the United States agreed to cut emissions to 26–28 percent below 2005 levels by the year 2025.

Plans are made to dedicate more federal land to energy development, utilizing untapped shale, oil, natural gas, and coal reserves found within the national parks.

In the largest reduction of protected federal lands, national monuments are shrunk, including Bears Ears by 85 percent and Grand Staircase-Escalante by 50 percent.

2018 Congress considers six bills that weaken the Endangered Species Act, favoring drilling, logging, and other economic activities over protecting plants, animals, and critical habitats.

Sources

Library of Congress. "Documentary Chronology of Selected Events in the Development of the American Conservation Movement, 1847–1920." May 3, 2002. http://lcweb2.loc.gov/ammem/amrvhtml/cnchron1.html.

National Park Service. "Conservation Timeline 1901–2000." Updated February 26, 2015. https://www.nps.gov/mabi/learn/historyculture /conservation-timeline-1901-2000.htm.

US Fish and Wildlife Service. "Endangered Species Act: A History of the Endangered Species Act of 1973: Timeline." Updated July 15, 2013. http:// www.fws.gov/endangered/laws-policies/timeline.html.

World Wildlife Fund. n.d. "History: From 1961 to Today." http:// www.worldwildlife.org/about/history.

EXHIBITION CHECKLIST

Chris and Dawn Agnos
American, b. 1977 and 1973
How Wolves Change Rivers, 2014
Video with sound, 4:33 minutes
Courtesy of Sustainable Human

Julie Andreyev and Simon Lysander Overstall
Canadian, b. 1962 and 1969
Salmon People, 2010–2015
Sample output from recombinant multi-channel audio-video installation, 12:00 minutes
Courtesy of the artists

Sara Angelucci
Canadian, b. 1962
Aviary (Female and Male Passenger Pigeons/ extinct), 2013
C-prints
38 x 26 in.
Courtesy of the artist

John James Audubon
American, 1785–1851
Passenger Pigeon, from *Birds of America*, vol. 5, plate 285; 1842
Hand-colored lithograph
10⅜ x 7 x 2⅛ in.
Courtesy of Linda Hall Library of Science, Engineering, and Technology, Kansas City, Missouri

The Great Auk, from *Birds of America*, vol. 7, plate 465; 1844
Hand-colored lithograph
10⅜ x 7 x 2⅛ in.
Courtesy of Linda Hall Library of Science, Engineering, and Technology, Kansas City, Missouri

Brandon Ballengée
American, b. 1974
DFB 39 Priapus, 2013, from the series *Malamp: The Occurrence of Deformities in Amphibians*
Cleared and stained Pacific tree frog collected in Aptos, California, in scientific collaboration with Stanley K. Sessions
Unique Iris print on Arches watercolor paper
46 x 34 in.
Courtesy of the artist and Ronald Feldman Fine Arts, New York

William P.C. Barton
American, 1786–1856
Cornus Florida L., from *Vegetable Materia Medica of the United States*, vol. 1, 1817–1818
Engraving, hand-colored by Esther Barton
10¼ x 7⅞ in.
Courtesy of Linda Hall Library of Science, Engineering, and Technology, Kansas City, Missouri

Antoine-Louis Barye
French, 1796–1875
Wolf Holding a Stag by the Throat, modeled 1843 (cast date unknown)
Bronze
15¼ x 5½ x 8½ in.
Collection of Whatcom Museum, Gift of Julie Ward, 1991.2.1

Daniel Beltrá
American and Spanish, b. 1964
Man-Made Fires to Clear the Land for Cattle or Crops: Amazon Rainforest, 2008
Archival digital print
40 x 60 in.
Courtesy of the artist

Large areas of savannah have been turned to fast-growing eucalyptus forests in the past decade to provide the Japanese and European paper-making industries, 2017
Archival digital print
40 x 60 in.
Courtesy of the artist

Nick Brandt
British, b. 1964
Line of Rangers Holding the Tusks of Elephants Killed at the Hands of Man, Amboseli, from *Across the Ravaged Land*, 2011
Archival pigment print
44 x 78 in.
Courtesy of the artist

Elephants Walking Through Grass, Amboseli, from *A Shadow Falls*, 2008
Archival pigment print
44 x 77 in.
Courtesy of the artist

Edward Burtynsky
Canadian, b. 1955
Salt River Pima-Maricopa Indian Community / Scottsdale, Arizona, 2011
Digital chromogenic color print
39 x 52 in.
©Edward Burtynsky, Courtesy Metivier Gallery, Toronto / Von Lintel Gallery, Los Angeles

George Catlin
American, 1796–1872
Buffalo Bull, Grazing on the Prairie, 1832–1833
Oil on canvas
24 x 29 in.
Smithsonian American Art Museum, Gift of Mrs. Joseph Harrison, Jr.

Catherine Chalmers
American, b. 1957
We Rule, from *Leafcutter* series, 2013
Video with sound, 4:12 minutes
Courtesy of the artist

David Chancellor
British, b. 1961
Untitled Hunter #1, Trophy Room, Dallas, Texas, 2011
from *Hunters*, 2013
Chromogenic print
54 x 34 in.
Courtesy of the artist

Xavier Cortada
American, b. 1964
The Reclamation Project, 2007
Video with sound by Bill Bilowit, 9:11 minutes
Courtesy of the artist

Reclamation Project / Reclaiming Mangroves: Reforestation of 2,500 mangrove seedlings on Virginia Key, FL, April 2008
Photograph
8 x 10 in.
Courtesy of the artist

Mark Dion
American, b. 1961
Conquistadors 1492–1992, 1992
Blueprint, edition of 10
17½ x 23½ in.
Courtesy of the artist and Tanya Bonakdur Gallery, New York

Scala Natura, 2008
Offset color lithograph
50½ x 40 in.
Courtesy of the artist and Tanya Bonakdur
Gallery, New York

Dornith Doherty
American, b. 1957
Millennium Seed Bank Research Seedlings and Lochner-Stuppy Test Garden No. 3, 2011
Digital chromogenic lenticular photograph
79 x 36 in.
Courtesy of the artist

Michael J. Felber
American, b. England, 1946
Arctic Father, 2017
Colored pencil
22½ x 30 in.
© Michael Felber 2018, Courtesy of the artist
Photo by Darryl Schmidt

Madeline von Foerster
American, b. 1973
Carnival Insectivora (Cabinet for Cornell and Haeckel), 2013
Oil and egg tempera on panel
20 x 16 in.
Collection of John Brusger

Reliquary for Rabbs' Frog, 2018
Oil and egg tempera on panel
8 x 13 in.
Courtesy of the artist

Nicholas Galanin
Tlinget-Aleut, b. 1979
Inert Wolf, 2009
Wolf pelts and felt
74 x 65 x 24 in.
Courtesy of Burke Museum of Natural
History and Culture, catalogue number
2012-83/1

Penelope Gottlieb
American
Montana Hibiscifolia, from *Invasive Species*
series, 2012
Limited edition print with passages of
hand coloring. Original: Acrylic and ink on
digitized John James Audubon print
36 x 25 in.
Courtesy of the artist

Passiflora vitifolia, from *Invasive Species*
series, 2012
Limited edition print with passages of
hand coloring. Original: Acrylic and ink on
digitized John James Audubon print
36 x 25 in.
Courtesy of the artist

Ernst Haeckel
German, 1834–1919
Hexacoralla, from *Kunstformen der Natur (Art Forms of Nature)*, 1904
Lithograph
14¼ x 11 x 1⅜ in.
Courtesy of Linda Hall Library of Science,
Engineering, and Technology, Kansas City,
Missouri

Martin Johnson Heade
American, 1819–1904
Cattleya Orchid, Two Hummingbirds and a Beetle, ca. 1875–1890
Oil on canvas
14¼ x 22¼ in.
Crystal Bridges Museum of American Art,
Bentonville, Arkansas, 2010.67
Photography by Amon Carter Museum of
American Art

Patricia Johanson
American, b. 1940
Linked Gardens (Bobolink), from *House and Garden* proposals, *1969*
Pencil, ink, and colored pencil on paper
17 x 22 in.
Courtesy of the artist

Saggitaria platyphylla—Planting Plan (Paths,
Bridges, Seats and Animal Islands), 1982
For Fair Park Lagoon, Dallas, Texas,
1981–1986
Conte crayon, ink, and pastel on vellum
37½ x 49½ in.
Courtesy of the artist

Saggitaria *Platyphylla, Fair Park Lagoon,
Dallas, Texas*, 1985
Photograph by William Pankey
8 x 10 in.
Courtesy of the artist

*Patricia Johanson: Fair Park Lagoon, Dallas,
Texas*, 1991
Video with sound by Jyoti Duwadi, 3:30
minutes
Courtesy of Jyoti Duwadi

Bat Bridge: Crossing Route 24, 1999
Pastel, pencil, ink, and charcoal on paper
9 x 11½ in.
Courtesy of the artist

Chris Jordan
American, b. 1963
Roundup, 2015
Archival inkjet print, made from 15 colored
pencil drawings of bees made by Helena S.
Eitel
60 x 60 in.
Courtesy of the artist

Harri Kallio
American, b. Finland, 1970
Dodo sculpture
1:1 scale dodo reconstruction (male), from
*The Dodo and Mauritius Island, Imaginary
Encounters*, 2001
Mixed media
34 x 12 x 20 in.
Courtesy of the artist

Les Gris Gris #3, Mauritius, from *The Dodo
and Mauritius Island, Imaginary Encounters*,
2004
Archival inkjet print
29½ x 36 in.
Courtesy of the artist

Sanna Kannisto
Finnish, b. 1974
Private Collection, 2003
Digital C-print
51 x 63 in.
Courtesy of the artist

Flower Arrangement, 2010
Digital C-print
27⅝ x 22½ in.
Courtesy of the artist

Darius Kinsey and Tabitha Kinsey
American, 1869–1945 and 1875–1963
*Man lying in the completed undercut of a
twelve-foot cedar*, 1906
Black-and-white photograph made from an
11 x 14 in. silver gelatin dry plate negative
Whatcom Museum, 1978.84.185

Isabella Kirkland
American, b. 1954
Gone, from the *Taxa* series, 2004
Oil and alkyd on canvas over panel
48 x 36 in.
Private Collection

Charles R. Knight
American, 1874–1953
Woolly Mammoth and Hunter, 1909
Oil on canvas
27½ x 39½ in.
Courtesy of American Museum of Natural
History, New York

Adam Kuby
American, b. 1961
Cliff Dwelling (proposal for a sculpture that
provides nesting habitat for peregrine falcons
on a skyscraper), 1993
Lithograph, pastel, and watercolor on paper
24 x 40 in.
Courtesy of the artist

Garth Lenz
Canadian
Alberta Tar Sands #3, from *Canada's Tar
Sands and the True Cost of Oil*, 2010
Archival pigment print
40 x 60 in.
Courtesy of the artist

David Liittschwager
American, b. 1961
Costa Rica Collage, from *A World in One Cubic Foot*, 2012
Archival inkjet prints
30 x 20 in. and 30 x 60 in.
Courtesy of the artist

John Martin
English, 1789–1854
Country of the Iguanadon, frontispiece of Gideon Mantell's *Wonders of Geology*, vol. 1, 1838
Steel mezzotint engraving
7 x 4¾ x 1¼ in.
Courtesy of Linda Hall Library of Science, Engineering, and Technology, Kansas City, Missouri

Courtney Mattison
American, b. 1985
Afterglow (Our Changing Seas VI), 2018
Site-specific installation for Whatcom Museum
Hand-sculpted and glazed stoneware and porcelain
7½ x 8½ x 1½ ft.
Courtesy of artist

Daniel McCormick and Mary A. O'Brien
American, b. 1950 and 1952
The Nature of Art, 2014
Video with sound, 4:36 minutes
Courtesy of Nevada Museum of Art, Center for Art + Environment Archive Collections and the Nature Conservancy of Nevada

Woven Flood Plain Wall, Carson River, 2014
Photograph by Mary A. O'Brien
8 x 10 in.
Courtesy of the artists

Susan Middleton and David Liittschwager
American, b. 1948 and 1961
Contents of Laysan Albatross Stomach and *Laysan Albatross Necropsy (moli Phoebastria immutabilis)*, 2004
Archival pigment print
30 x 60 in.
Courtesy of the artists

David W. Miller
American, b. 1957
Deinonychus and Multituberculate mammal, 1998
Oil on illustration board
21½ x 18½ in.
Courtesy of the artist

Quetzalcoatlus, 2002
Oil and acrylic on illustration board
16 x 12 in.
Courtesy of New York State Museum, Albany

Macoto Murayama
Japanese, b. 1984
Commelina communis L.—front view - ow, 2011
C-print
39½ x 39½ in.
Courtesy of Frantic Gallery, Tokyo

Édouard Riou
French, 1833–1900
Apparition de L'homme (Appearance of Man), from Louis Figuier's *Terre avant le Déluge (The World before the Deluge)*, 1866
Engraving
9½ x 6¾x 1⅜ in.
Courtesy of Linda Hall Library of Science, Engineering, and Technology, Kansas City, Missouri

Alexis Rockman
American, b. 1962
Fragments, 2010
Watercolor and ink on paper
24 x 18 in.
Collection of Lemur Conservation Foundation, Myakka City, Florida

Untitled (Madagascar 6), 2010
Pencil and watercolor
7 x 10 in.
Courtesy of the artist

Christy Rupp
American, b. 1949
Great Auk, from *Extinct Birds Previously Consumed by Humans*, 2005–2008
Steel, chicken bones, mixed media
30 x 17 x 21½ in.
Courtesy of the artist

Joel Sartore
American, b. 1962
Captive Northern Spotted Owl, Merlin, Oregon, 2007
Archival inkjet print
30 x 45 in.
©Joel Sartore, Courtesy of the artist

Preston Singletary
American Tlingit, b. 1963
Killer Whale, made at Museum of Glass, 2009
Blown glass and sand-carved glass
25 x 16 x 7 in.
Collection of Museum of Glass, Tacoma, Washington, Gift of the artist

Brian Skerry
American, b. 1961
Bycatch—In a cascade of death, guitarfish, rays, and other bycatch are tossed from a shrimp boat in the Gulf of California, Mexico, 2005
C-print
32 x 48 in.
Courtesy of the artist

Carl Strüwe
German, 1898–1988
Diatoms Actinoptychus heliopelta, 1928, printed late 1950s
Gelatin silver print, edition 1 of 11, titled and stamped by photographer verso
6⅛ x 5⅛ in.
© 2017 by Carl Strüwe Archive, Prof. Dr. Gottfried Jäger, Bielefeld/VG Bild-Kunst, Bonn, Germany
Courtesy of Steven Kasher Gallery, New York

Butterfly (Red Admiral), Scales on Wing (Ala papilionis), 1928, printed 1960s–1970s
Gelatin silver print, edition 1 of 9, stamped by photographer verso
9½ x 7 in.
© 2017 by Carl Strüwe Archive, Prof. Dr. Gottfried Jäger, Bielefeld/VG Bild-Kunst, Bonn, Germany
Courtesy of Steven Kasher Gallery, New York

Archetype of Collectibe (Sertularia millifolium), 1933, printed 1960s–1970s
Gelatin silver print, edition 1 of 8, signed and stamped by photographer verso
9½ x 7 in.
© 2017 by Carl Strüwe Archive, Prof. Dr. Gottfried Jäger, Bielefeld/VG Bild-Kunst, Bonn, Germany
Courtesy of Steven Kasher Gallery, New York

Foraminifera, Protozoa, and Plankton, 1936, printed 1960s–1970s
Gelatin silver print, edition 7 of 7, stamped by photographer verso
9⅝ x 7⅛ in.
© 2017 by Carl Strüwe Archive, Prof. Dr. Gottfried Jäger, Bielefeld/VG Bild-Kunst, Bonn, Germany
Courtesy of Steven Kasher Gallery, New York

Jason deCaires Taylor
British, b. 1974
Photograph of *Vicissitudes, Grenada, West Indies*, featured in video, 2011
8 x 10 in.
Courtesy of the artist

Jason deCaires Taylor and Museo Subacuático de Arte (MUSA), 2011
Video with sound, 6:36 minutes
Courtesy of the artist

Fred Tomaselli
American, b. 1956
Gravity in Four Directions, 2001
Leaves, pills, printed paper, acrylic and resin on wood
72 x 72 in.
Courtesy of Paul G. Allen Family Collection
Photo: Spike Mafford

Tom Uttech
American, b. 1942
Nin Maminawendam, 2006
Oil on canvas
73¼ x 78¾ in.
Collection of the Tucson Museum of Art,
Gift of the Contemporary Art Society,
2009.5.1

Roman Vishniac
American, b. Russia, 1897–1990
Cross Section of a Pine Needle, early 1950s–late
1970s, printed 2017
Archival digital inkjet print
9 x 13 in.
© Mara Vishniac Kohn, Courtesy
International Center of Photography, New
York

Jason Walker
American, b. 1973
A Hand in Two Worlds, from the series
Human Made Wild, 2008
Porcelain, underglaze, luster, and concrete
13½ x 19 x 7 in.
Collection of Deb McCunn

Andy Warhol
American, 1928–1987
Endangered Species, 1983
*Siberian Tiger (Leo tigris altaica); Pine
Barrens Tree Frog (Hyla andersonii);
African Elephant (Loxodonta africana);
Giant Panda (Ailuropoda melanoleuca); Bald
Eagle (Haliaeetus leucocephalus); Bighorn
Ram (Ovis canadensis); Black Rhinoceros
(Diceros bicornis); San Francisco Silverspot
(Speyeria callippe callippe); Orangutan (Pongo
pygmaeus); Grevy's Zebra (Equus grevy)*
10 silkscreen prints
38 x 38 in.
© 2018 The Andy Warhol Foundation for
the Visual Arts / Artists Rights Society
(ARS), New York / Ronald Feldman Fine
Arts, New York
Photo: D. James Dee

Yang Yongliang
Chinese, b. 1980
Infinite Landscape, 2010
HD video, 7 minutes
Courtesy of the artist

Lawrence Paul Yuxweluptun
Canadian First Nations (Coast Salish-
Okanagan), b. 1957
Clear Cut to the Last Tree, 1993
Screen print on paper
28 x 18 in.
Collection of the Vancouver Art Gallery,
Vancouver Art Gallery Acquisition Fund,
VAG 94.14.1

BIBLIOGRAPHY

Ackerman, Jennifer. *The Genius of Birds*. New York: Penguin Press, 2016.

Aloi, Giovanni. *Art and Animals*. New York: I. B. Tauris, 2012.

Archibald, J. David. *Aristotle's Ladder, Darwin's Tree: The Evolution of Visual Metaphors for Biological Order*. New York: Columbia University Press, 2014.

Art in Action: Nature, Creativity and our Collective Future. San Rafael: Earth Aware Editions, 2007.

Ashworth, William B., Jr. *Blade and Bone: The Discovery of Human Antiquity*. Kansas City, MO: Linda Hall Library of Science, Engineering, and Technology, 2012: http://bladeandbone.lindahall.org/index.shtml.

———. *The Grandeur of Life: A Celebration of Charles Darwin and the Origin of Species*. Kansas City, MO: Linda Hall Library of Science, Engineering, and Technology, 2009-2010: http://darwin.lindahall.org/.

———. *Paper Dinosaurs: 1824–1969*. Kansas City, MO: Linda Hall Library of Science, Engineering, and Technology, 1997, updated 2009: http://dino.lindahall.org/index.shtml.

Audubon, John James. *The Birds of America, from Drawings Made in the United States and their Territories*. New York: J. J. Audubon; Philadelphia: J. B. Chevalier, 1840-1844.

Baione, Tom, ed. *Natural Histories: Extraordinary Rare Book Selections from the American Museum of Natural History Library*. New York: Sterling Signature, 2012.

Baker, Steve. *Artist/Animal*. Minneapolis: University of Minnesota Press, 2013.

———. *Fieldwork: Sanna Kannisto*. New York: Aperture, 2011.

Barrow, Mark V., Jr. *Nature's Ghosts: Confronting Extinction from the Age of Jefferson to the Age of Ecology*. Chicago: University of Chicago Press, 2009.

Bateman, Robert. *Natural Worlds*. New York: Simon & Schuster, 1996.

Beard, Peter. *The End of the Game*. Vancouver, BC: Raincoast Books, 1963.

Bleichmar, Daniela. *Visible Empire: Botanical Expeditions and Visual Culture in the Hispanic Enlightenment*. Chicago: University of Chicago Press, 2012.

Brandt, Nick. *Across the Ravaged Land*. New York: Abrams, 2013.

Brown, Andrew. *Art & Ecology Now*. New York: Thames & Hudson, 2014.

Butler, Tom, ed. *Overdevelopment, Overpopulation, Overshoot*. San Francisco: Goff Books, 2015.

Ceballos, Gerardo, Anne H. Ehrlich, and Paul R. Ehrlich. *The Annihilation of Nature: Human Extinction of Birds and Mammals*. Baltimore: Johns Hopkins University Press, 2015.

Ceballos, Gerardo, Paul R. Ehrlich, and Rodolfo Dirzo. "Biological Annihilation via the Ongoing Sixth Mass Extinction Signaled by Vertebrate Population Losses and Declines." *Proceedings of the National Academy of Sciences of the United States* 114, no. 30 (May 2017): 1-8. https://doi.org/10.1073/pnas.1704949114.

Challenger, Melanie. *On Extinction*. Berkeley: Counterpoint Press, 2012.

Corrin, Lisa G., Miwon Kwon, and Norman Bryson. *Mark Dion*. London: Phaidon Press, 1997.

Czerkis, Sylvia Massey, and Donald F. Glut. *Dinosaurs, Mammoths and Cavemen: The Art of Charles Knight*. New York: E.P. Dutton, 1982.

Donald, Diana, and Jane Munro, eds. *Endless Forms: Charles Darwin, Natural Science and the Visual Arts*. New Haven: Yale University Press, 2009.

Duffek, Karen, Tania Willard, Glen Alteen, Lucy Lippard, and Michael Turner. *Lawrence Paul Yuxweluptun: Unceded Territories*. Vancouver: Museum of Anthropology, University of British Columbia, 2016.

Flannery, Tim and Peter Schouten. *A Gap in Nature: Discovering the World's Extinct Animals*. New York: Atlantic Monthly Press, 2001.

Franco, José Luiz de Andrade. "The Concept of Biodiversity and the History of Conservation Biology: From Wilderness Preservation to Biodiversity Conservation." *História (São Paulo)* 32, no.2. (July/Dec. 2013): http://www.scielo.br/scielo.php?pid=S0101-90742013000200003&script=sci_arttext&tlng=en.

Friedewald, Boris. *A Butterfly Journey: Maria Sibylla Merian, Artist and Scientist*. Munich: Prestel, 2015.

Gast, Ellen ter, and Ine Gevers, eds. *Yes Naturally: How Art Saves the World*. Amsterdam: Niet Normaal Foundation, 2013.

Geyer, Roland, Jenna R. Jambeck, and Kara Lavender Law. "Production, Use, and Fate of All Plastics Ever Made," *Science Advances* 3, no. 7 (July 19, 2017): http://advances.sciencemag.org/content/3/7/e1700782.full.

Gillam, Casey. *Whitewash: The Story of a Weed Killer, Cancer, and the Corruption of Science*. Washington, DC: Island Press, 2017.

Glavin, Terry. *The Sixth Extinction: Journeys Among the Lost and Left Behind*. New York: Thomas Dunne Books, 2007.

Gould, Stephen Jay. *Leonardo's Mountain of Clams and the Diet of Worms*. New York: Harmony Books, 1998.

Hallmann Caspar A., Martin Sorg, Eelke Jongejans, Henk Siepel, Nick Hofland, Heinz Schwan et al. "More than 75 Percent Decline over 27 Years in Total Flying Insect Biomass in Protected Areas." PLoS ONE 12 (October 18, 2017): https://doi.org/10.1371/journal.pone.0185809.

Harari, Yuval Noah. *Sapiens: A Brief History of Humankind*. New York: HarperCollins, 2015.

Harris, Adam Duncan. *George Catlin's American Buffalo*. Washington, DC: Smithsonian American Art Museum, 2013.

———. *Wildlife in American Art: Masterworks from the National Museum of Wildlife Art*. Norman: University of Oklahoma Press, 2009.

Harris, George and Annette Schroeder. *A Bad Colonial Day: Lawrence Paul Yuxweluptun*. Prince George, BC: Two Rivers Gallery, 2005.

Hatcher, Paul. *Biological Diversity: Exploiters and Exploited*. Chichester, England: Wiley-Blackwell, 2011.

Huxley, Robert, ed. *The Great Naturalists*. London: The Natural History Museum, Thames & Hudson, 2007.

Kallio, Harri. *The Dodo and Mauritius Island: Imaginary Encounters*. Stockport, England: Dewi Lewis Publishing, 2004.

Kelley, Caffyn. *Art and Survival: Patricia Johanson's Environmental Projects*. Salt Spring Island, BC: Islands Institute of Interdisciplinary Studies, 2006.

Knight, Charles. *Life Through the Ages*. New York: Alfred A. Knopf, 1946.

Kolbert, Elizabeth. *The Sixth Extinction: An Unnatural History*. New York: Henry Holt, 2014.

Laytner, Anson, and Dan Bridge, trans. *The Animals' Lawsuit Against Humanity: A Modern Adaptation of an Ancient Animal Rights Tale*. Louisville: Fons Vitae, 2005.

Liittschwager, David. *A World in One Cubic Foot: Portraits of Biodiversity*. Chicago: University of Chicago Press, 2012.

Liittschwager, David, and Susan Middleton. *Here Today: Portraits of Our Vanishing Species*. San Francisco: Chronicle Books, 1991.

Mancuso, Stefano, and Alessandra Viola. *Brilliant Green: The Surprising History and Science of Plant Intelligence*. Washington, DC: Island Press, 2015.

Matilsky, Barbara. *Fragile Ecologies: Contemporary Artists' Interpretations and Solutions*. New York: Rizzoli International, 1992.

———. *Vanishing Ice: Alpine and Polar Landscapes in Art, 1775–2012*. Bellingham, WA: Whatcom Museum, 2012.

MacLeod, Norman. *The Great Extinctions: What Causes Them and How They Shape Life*. Buffalo, NY: Firefly Books, 2013.

McCartha, Madison. Interview with Catherine Chalmers. *Yield*, no. 4 (November 2016): 68–90. http://004.yieldmagazine.org /yield-no4-impressum/.

Mee, Margaret. *In search of Flowers of the Amazon Forests*. Woodbridge, England: Nonesuch Expeditions, 1988.

Neff, Emily. *The Modern West: American Landscapes, 1890–1950*. Houston: Museum of Fine Arts, 2006.

Nemitz, Barbara, ed. *Trans/Plant: Living Vegetation in Contemporary Art*. Ostfildern-Ruit, Germany: Hatje Cantz Publishers, 2000.

Novak, Barbara. *Nature and Culture: American Landscape and Painting, 1825–1875*. New York: Oxford University Press, 1981.

Olson, Roberta J.M. *Audubon's Aviary: The Original Watercolors for The Birds of America*. New York: New-York Historical Society, 2012.

Pretty, Jules. *The Edge of Extinction: Travels with Enduring People in Vanishing Lands*. Ithaca: Cornell University Press, 2014.

Prince, Sue Ann, ed. *Of Elephants & Roses: French Natural History 1790–1830*. Philadelphia: American Philosophical Society, 2013.

Quammen, David. *The Song of the Dodo: Island Biogeography in an Age of Extinctions*. New York: Scribner, 1996.

Ripple, William J., Katharine Abernethy, Matthew G. Betts, Guillaume Chapron, Rodolfo Dirzo, Mauro Galetti, Taal Levi et al. "Bushmeat Hunting and Extinction Risk in the World's Mammals," *Royal Society Open Science* 3, (2016): http://dx.doi .org/10.1098/rsos.160498.

Rudwick, Martin. *Earth's Deep History: How It was Discovered and Why It Matters*. Chicago: University of Chicago Press, 2014.

———. *Scenes from Deep Time: Early Pictorial Representation of the Prehistoric World*. Chicago: University of Chicago Press, 1992.

Rutkow, Eric. *American Canopy: Trees, Forests, and the Making of a Nation*. New York: Scribner, 2012.

Safina, Carl. *Beyond Words: What Animals Think and Feel*. New York: Henry Holt, 2015.

Sheehy, Colleen J., ed. *Cabinet of Curiosities: Mark Dion and the University as Installation*. Minneapolis: University of Minnesota Press, 2006.

Shryock, Andrew, and Daniel Lord Smail, eds. *Deep History: The Architecture of Past and Present*. Berkeley: University of California Press, 2012.

Spaid, Sue. *A Field Guide to Patricia Johanson's Works: Built, Collected and Published*. Baltimore: Contemporary Museum, 2012.

Speth, James Gustave. "Environmental Pollution: A Long-Term Perspective." Reprinted from *Earth '88, Changing Geographic Perspectives*. Washington, DC: National Geographic Society, 1988. https://www.wri.org/sites/default/files/pdf /environmentalpollution_bw.pdf.

Stebbins, Theodore E., Jr., Janet L. Comey, Karen E. Quinn, and Jim Wright. *Martin Johnson Heade*. Boston: Museum of Fine Arts, 1999.

Stott, Rebecca. *Darwin's Ghosts: The Secret History of Evolution*. New York: Spiegel & Grau, 2012.

Vidal, Fernando, and Nélia Dias, eds. *Endangerment, Biodiversity and Culture*. London: Routledge, 2016.

Ward, Peter D. *Under A Green Sky*. New York: HarperCollins, 2007.

Warhol, Andy, and Kurt Benirschke. *Vanishing Animals*. New York: Springer-Verlag, 1986.

Whyte, John, and E.J. Hart. *Carl Rungius: Painter of the Western Wilderness*. Salem, NH: Salem House, 1985.

Wilson, Edward O. *The Future of Life*. New York: Alfred A. Knopf, 2002.

———. *Half-Earth: Our Planet's Fight for Life*. New York: Liveright Publishing, 2016.

Wu, Xin. *Patricia Johanson's House and Garden Commission: Reconstruction of Modernity*. Washington DC: Dumbarton Oaks, 2007.

Wulf, Andrea. *The Invention of Nature: Alexander von Humboldt's New World*. New York: Alfred A. Knopf, 2015.

Wythe, John van. *The Darwin Experience: The Story of the Man and His Theory of Evolution*. Washington, DC: National Geographic Society, 2008.

INDEX